a sleeping man (with nightmares with expired dates)

PHAIDON
non mint copy

Nedko Solakov

99.99* Fears

Φ

Fears

2006-07
by Nedko Solakov (me)
99 drawings
Black, sepia and white ink and
wash on paper
each 19 x 28 cm (appox.)

Courage

by Suzaan Boettger

A little fear was trying to do his job – spreading fear vibes all around. Unfortunately no one got affected just because there was nobody around. "Sometimes it is pretty scary to be alone" said the little fear to himself and slowed down a bit.

conor '06

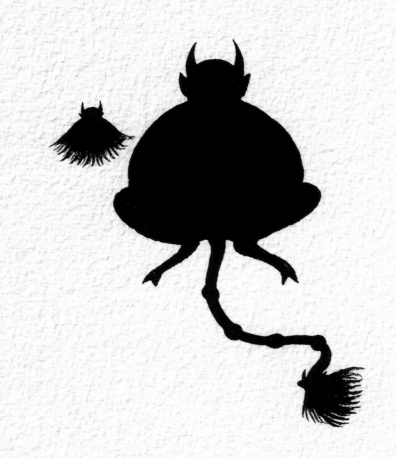

A devil is engaged in a strange activity. He keeps producing small, quite cute, devils out of his tail. He is quite happy. On the other hand, his tail gets this fear that maybe she is not doing the right thing.

corax '06

Somewhere in this stormy sea there is a tiny fish. She is not scared at all, although she feels a bit dizzy.

CORAK '06

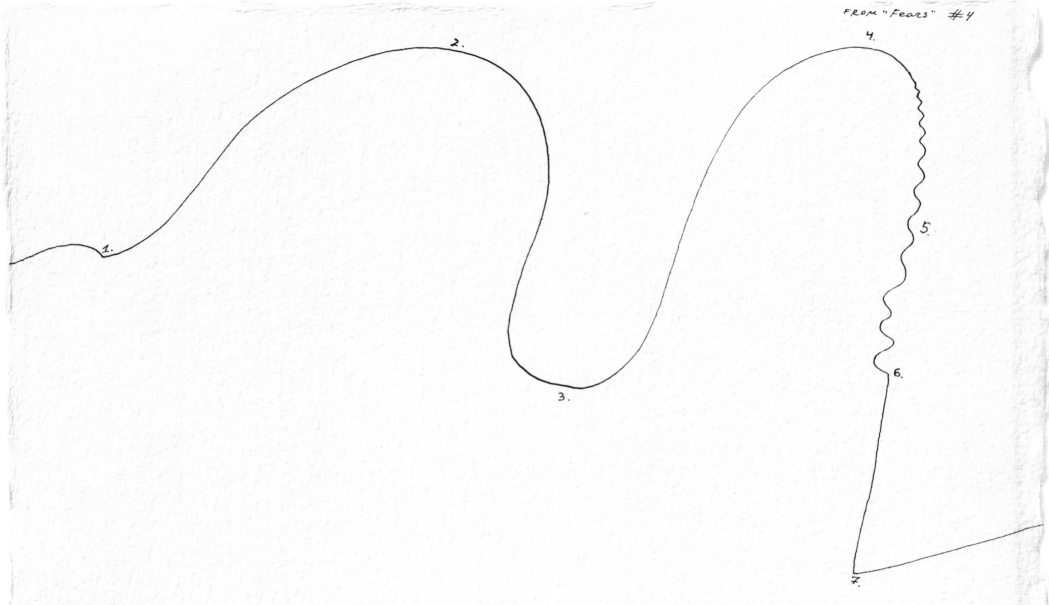

A visual presentation of an ordinary man's emotional status during an average day in his life: 1→ he wakes up; 2→ works his average job; 3→ feels sleepy in the afternoon (while at work); 4→ works again; 5→ fears going back home and being with his wife; 6→ meets her and →7→ falls asleep till the next morning.

coran '06

Two people are dancing. they feel especially happy because they left all their daily fears aside in order to feel more free and relaxed. they will collect the fears back later.

COREK '06

Two spooky creatures — a big fella and a little ghost, have an agreement: none of them should ever scare to death the other's friends. Only a small, healthy fear is permitted.

COLAK '06

FROM "FEARS" #7.

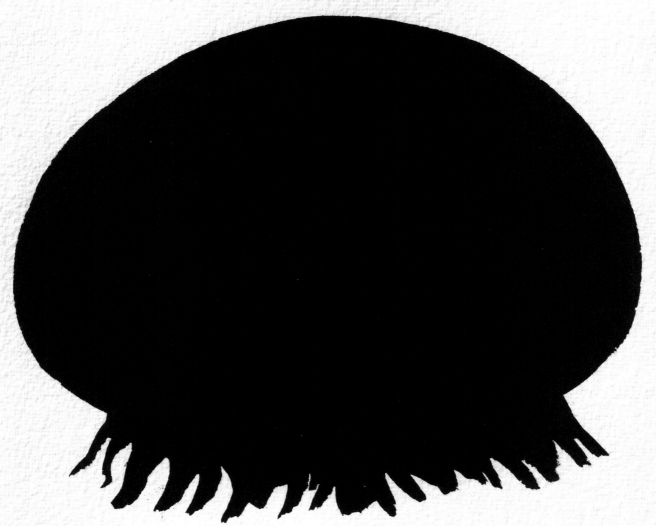

A chubby jellyfish has a fear of deep waters. Here she is: almost out on the beach trying not
to touch swimming ladies with big breasts.

COLAX'06

A little man suddenly got a fear from something he was not able to identify.

COMAK '06

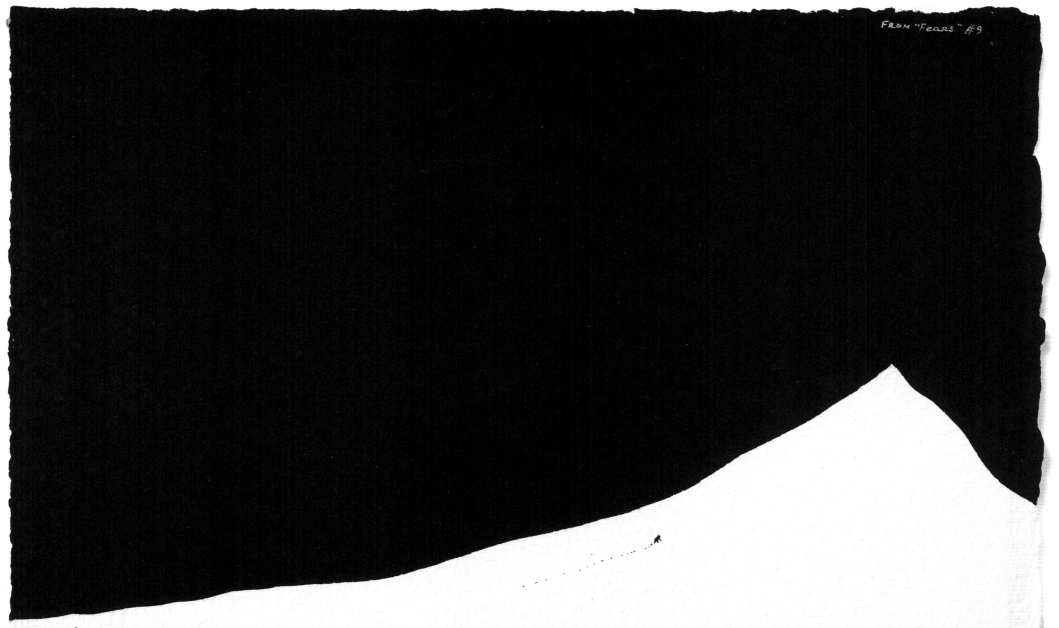

From "Fears" #9

A fearless adventurer is on his way to climb up his last mountain. After that he will only stay home, reading newspapers, drinking tea and picking his nose. This is the daydreaming in his head right now. He is used to it. Actually, this really will be his last mountain. An avalanche is coming.

COLAK '06

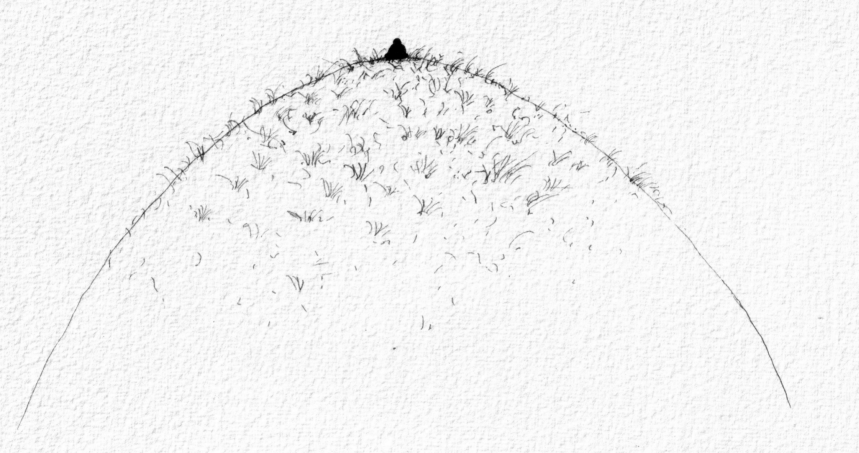

A MAN is already in heaven. It's kind of nice and calm although he still keeps his life-long fear of dying one day.

A big fear, a medium-sized fear and a small fear decided to work together on a family of four.

COHAK '06

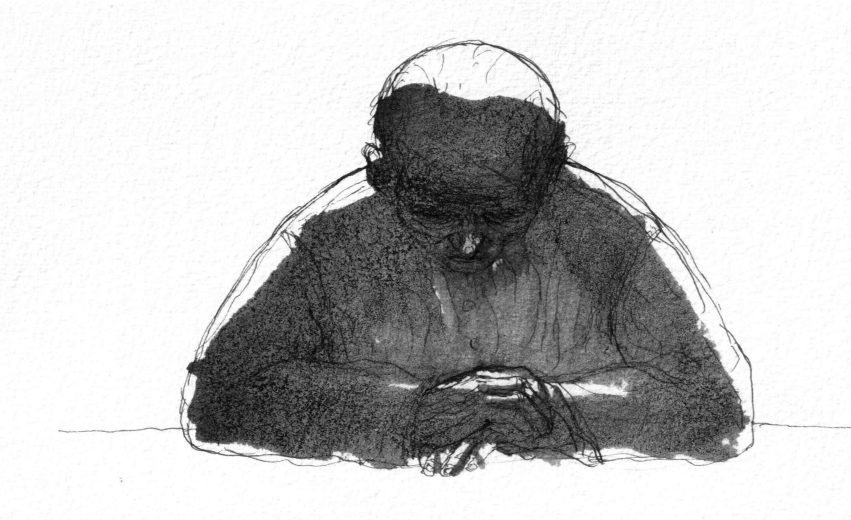

AN old university professor from a poor Eastern-European country has no more fears. He is only starving.

colan '06

A sharing-all-of-our-fears line of losers is moving slowly. The leader is desperately waiting for another participant to touch his right hand and **download** the enormous fears-coming-from-everybody burden. So far, NO sign of a potential NEW leader.

COLAK '06

```
                    I
          T        H S        D   j  K
        P        F  E  A  R   Q      W
          M            C      L  X Y Z
        u      V  B        N        O
```

1 2 3 4 5 6 7 8 9 10 11 12 13 14 15 16 17 18 19 20 21 22 23 24

A bunch of letters (AKA Alphabet) is sending a warning message to an endless line of figures/digits. It is a cheap threat though because the forces are quite unequal. The digits know that they could easily describe the 26 letters while the letters can do little to the endless line. The only good (for the letters) thing is that 4 of them feel a bit more special, for the time being.

CONAK '06

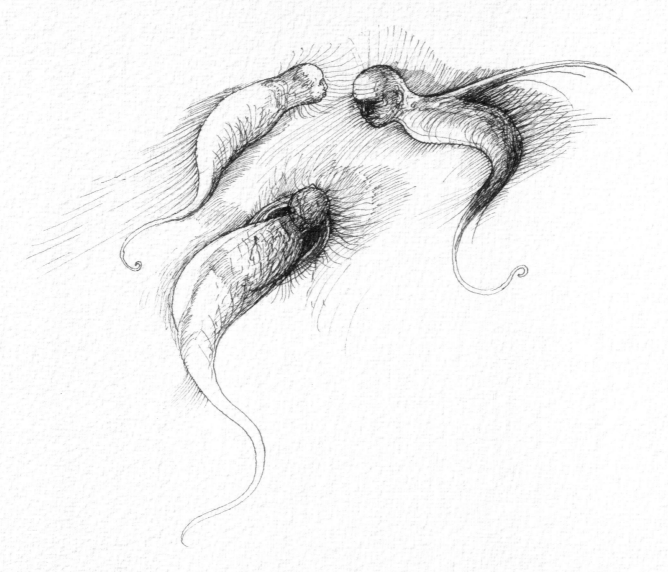

These creatures have fear of nothing. Are they happy? Not really.

CONK '06

the man on the ground has a fear of heights so he rather prefers to have this burden on top of himself
than be on the top. actually NONE of the others would let him be on the top because his corax'06
feet smell.

Two lines are ... are ... are ... (here the artist-me, gets stuck because he doesn't know how to develop the story). A fear appears on this sheet of paper. Not a big one but with a good potential for future growth.

COROK '06

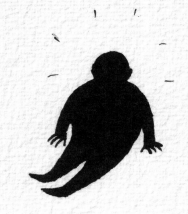

A middle-aged man is faithful to his wife (by his own standards). at the same time he has this enormous desire to touch (and play with, maybe) other women's parts. as a result he keeps being scared and conscience stricken, which is entertaining, too.

CLARK '06

A tiny piece of hope is not scared of living in a deep black darkness. For the time being....

CORAK '06

I am extremely scared of flying. Tomorrow I'll have to fly again. If there is a drawing #21, I will be able to be scared in the future, too.

conar '06

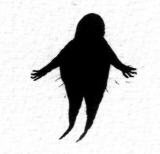

What a (temporary) relief! I will be able to be scared in the future too...

CONK '06

A baby-moon is released by its mother-moon to shine on its own. The glowing is a bit lowkey which confirms the mother's fears that **may not be** enough space for 2 moons in that part of the universe.

CONAK '06

A young soldier is bravely marching on to meet the enemy. He feels no fear. He is a bit stupid too.

COMK '06

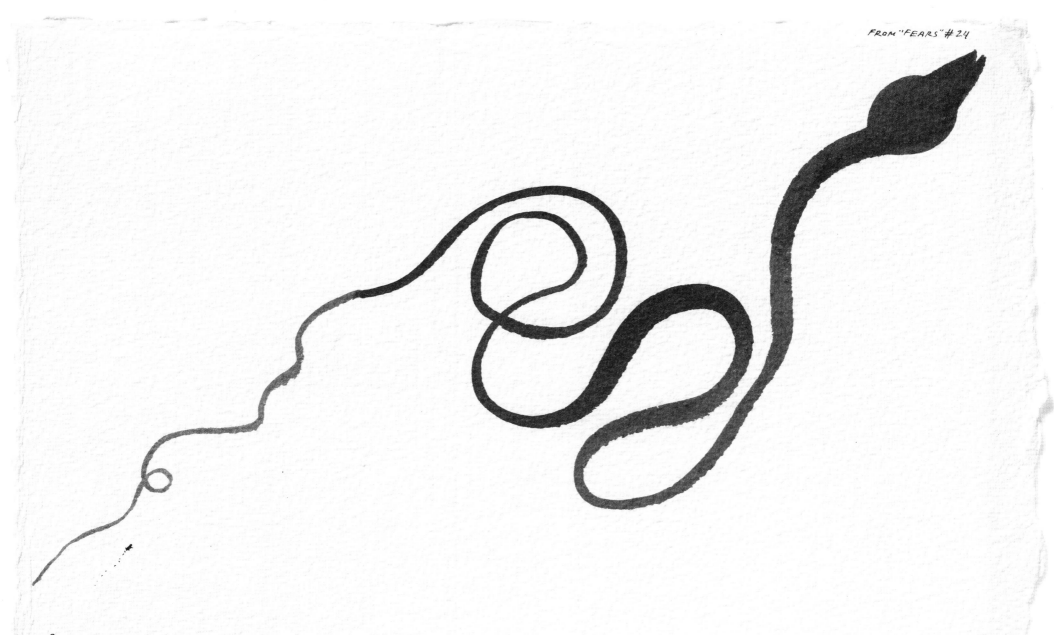

A pretty long, starving to death, snake just swallowed a juicy piece of animal. The snake's tail part was almost certain that it would be too late when the juicy animal's juices **reached** her. "Maybe I'll die first?" the tail said to a passing by ant. "Good for me!" the ant replied and **sat** waiting.

conak'06

and the fire described the PREVIOUS
day (where he SAVED 7 people
from a burning house, allegedly).

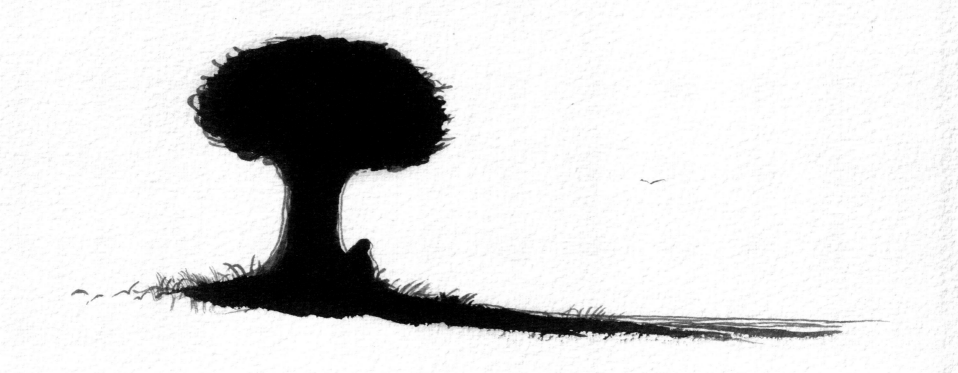

A pilgrim is taking a rest under an old tree. "It's so nice to contemplate the sea, the waves are so
beautiful" he is writing in his diary. Actually there is no sea around just an endless field that resembles
an ocean somewhat. But the pilgrim is afraid that his diary would not be
interesting enough, HENCE
the sea, cont '06

there is this fog which is so thick that nothing can be seen (look above - nothing!). Somewhere, 100 meters
ahead there is a rabbit who is on the way from one of his shelters to another:
a better for suchaweather, hole. 50 meters on our left there is a hungry fox. She sniffs out
the rabbit. The rabbit gets her smell too. one of them is really scared. Apparently this is the fox conak'06
for the clever rabbit put on some of the Best Hunter Stink stuff eau de toilette before making
the risky journey.

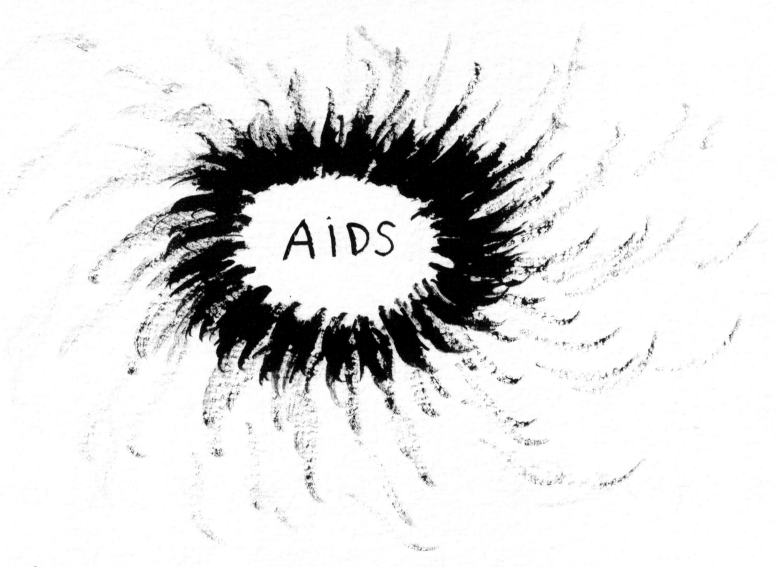

AIDS

one of my biggest fears (sometimes — the biggest). and I am not really screwing around.

CORAK '06

A city and a sea became one thing. Most of the citizens married fishes. There was one octopus though who remained a Bachelor – it was too scary for him to have a wife with 3 legs and 1 arm only.

Some curators have real fears of artists, that's why they (the curators) behave in a strange way which most of the time scares away the actual works of art (that's the reason they are not in the picture).

COOK '06

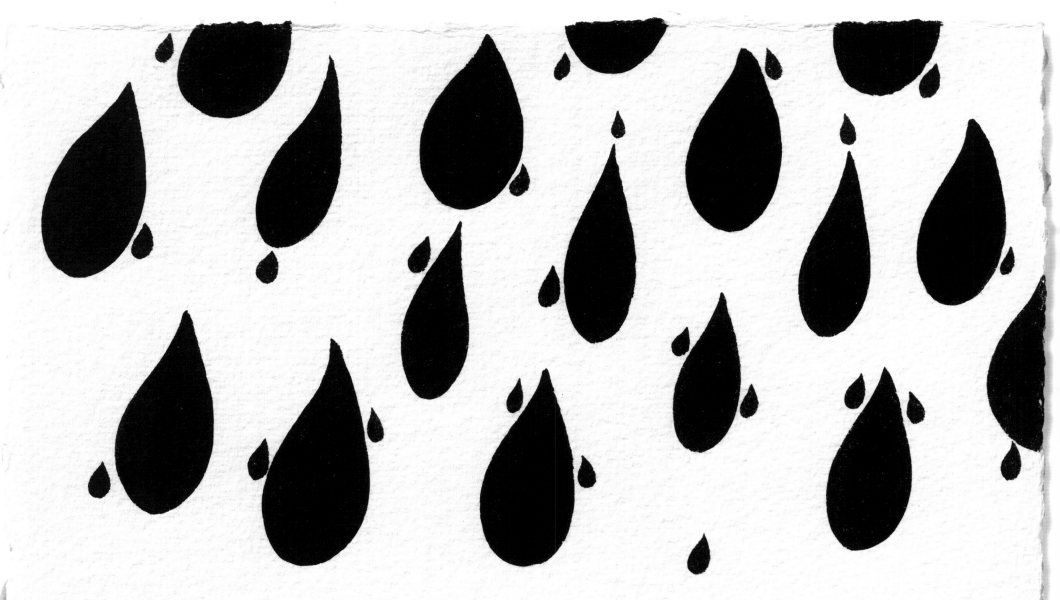

Mature raindrops are falling down. Today is a very exciting day because they are giving a lesson to their children — baby raindrops, which is the best way to perform their duty. A little guy is on his own — he is an orphan, unfortunately. He is doing well, almost leading the entire group. No fear in this story, which is a good thing, too.

FROM "FEARS" #30. COLOR '06

AN ALBINO Black hole feels very uncomfortable. Despite the enormous energy in her possesion Nobody (from that area) takes her seriously." Maybe I should swallow up some stars or something.... Nobody fears me properly." she said to herself while trying to look more fierce in that bloody write.

CONAK '06

one of the men has a lot of money. He likes to feel the actual notes. Here he is — surrounded by a lot of cash. The other man has no money but in order to feel no less important he's spread plenty of money-size papers around him. The thing is that from a distance it is almost impossible to say who is who. This is the man-with-the-money's biggest fear: NOT TO BE RECOGNISED AS A RICH MAN.

CORAK '06

AN improbable STORY— an old lady suddenly got the same fear of somebody "taking her flower" as in the days when she was young. What a burden on the top of her head — out of the blue. "What shall I do now? Avoiding boys again?" she was murmuring.

CONAK '06

Good luck to my beloved people!

After all, this is the only thing that matters. good luck! P.S. Because I made a mistake above, then corrected it, I have worak'06
to write it again: good luck to my beloved people!

Two friends are arguing over a piece of disabled fear. Each of them would like the other to take it and use it (and to be happier, eventually).

cohan '06

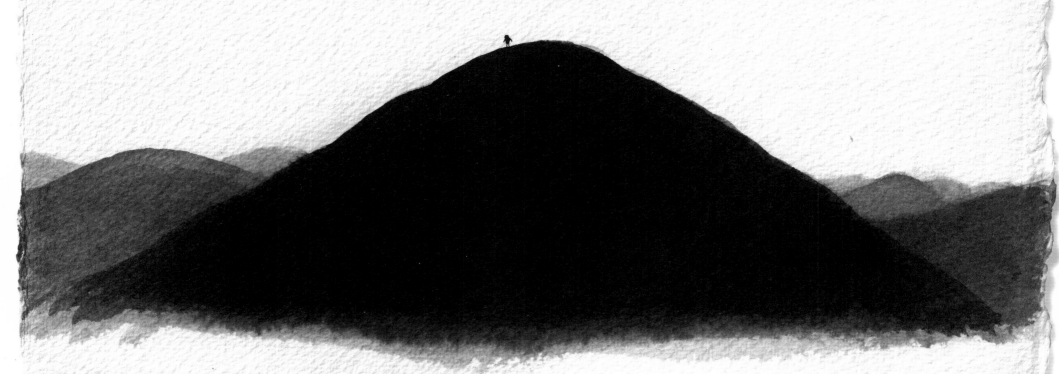

An apprentice devil was sent to the Earth. His mission was a secret, only a local bad guy knew about it. The bad guy was supposed to meet the devil apprentice on the top of that mountain and to hand him further instructions. However, at a certain moment the local bad guy had the feeling that the devil (apprentice)'s status is not relevant to his own, much higher, one. "Why did I keep that standard of bad behaviour? To deal with an apprentice now?!" the bad guy got a real fear of destroying his bad image.

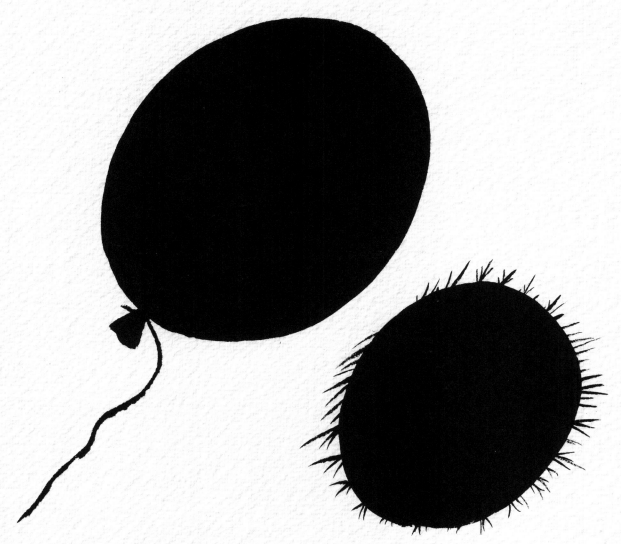

A balloon and a cactus became friends. For the time being - everything ok. The cactus' pricks are minding the tender balloon, and the balloon keeps itself close to the ground for better chat with the cactus (even though the balloon can easily go 56 meters high). CONRAD '06

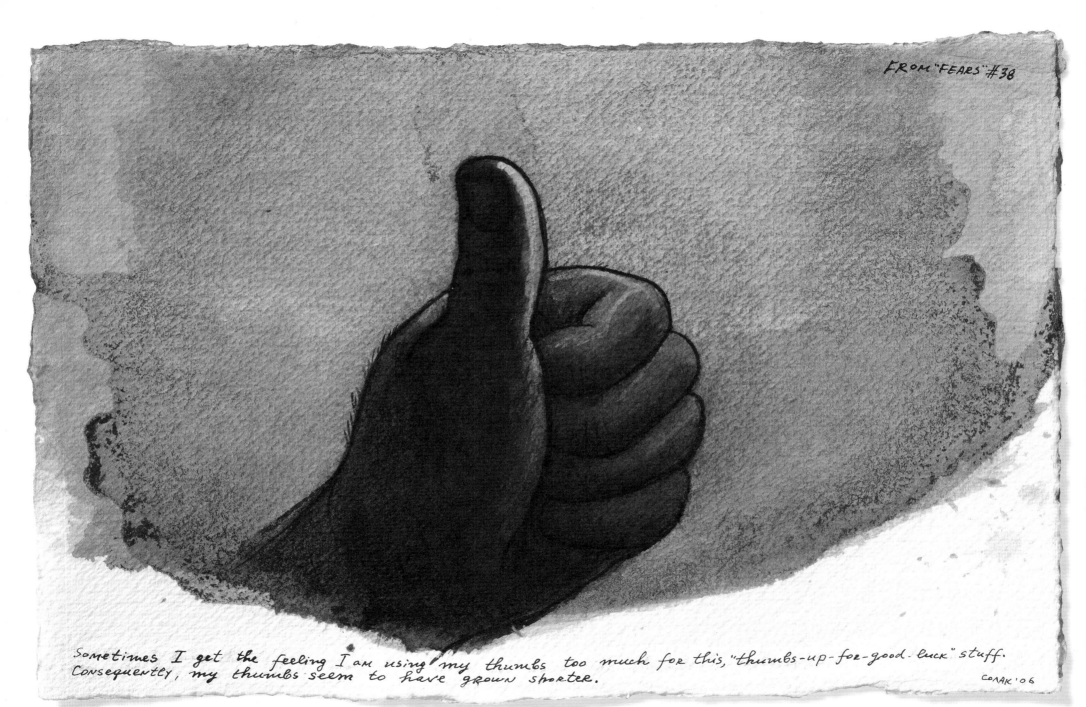

Sometimes I get the feeling I am using my thumbs too much for this, "thumbs-up-for-good-luck" stuff. Consequently, my thumbs seem to have grown shorter.

CLAK '06

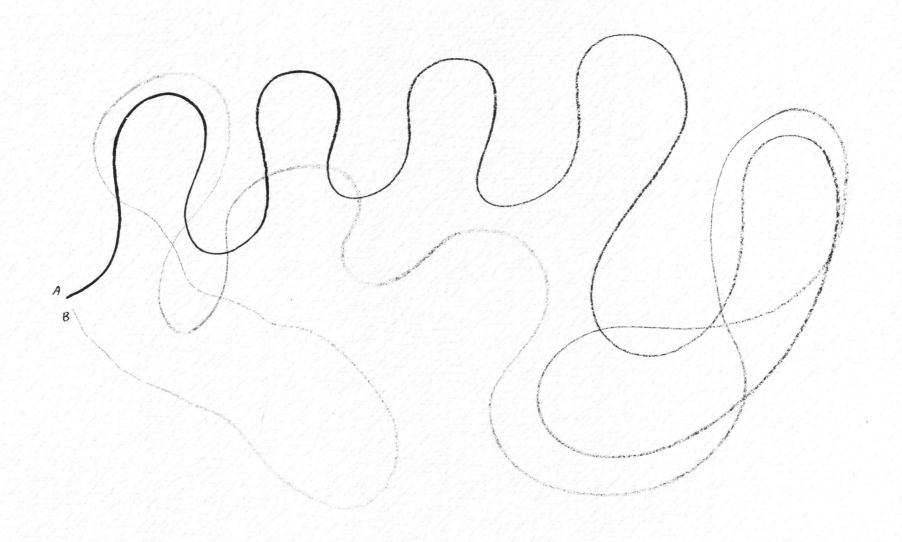

"Help me, please, I'm disappearing!" - B said to A. "No, I will not help you. I've told you before not to loiter around and to stay in one place like me!" was A's response. "But I was afraid of becoming too conservative if I had stayed in one place only." B added. "Being conservative is good. That's why I'm still visible and you will disappear soon" A said finally.

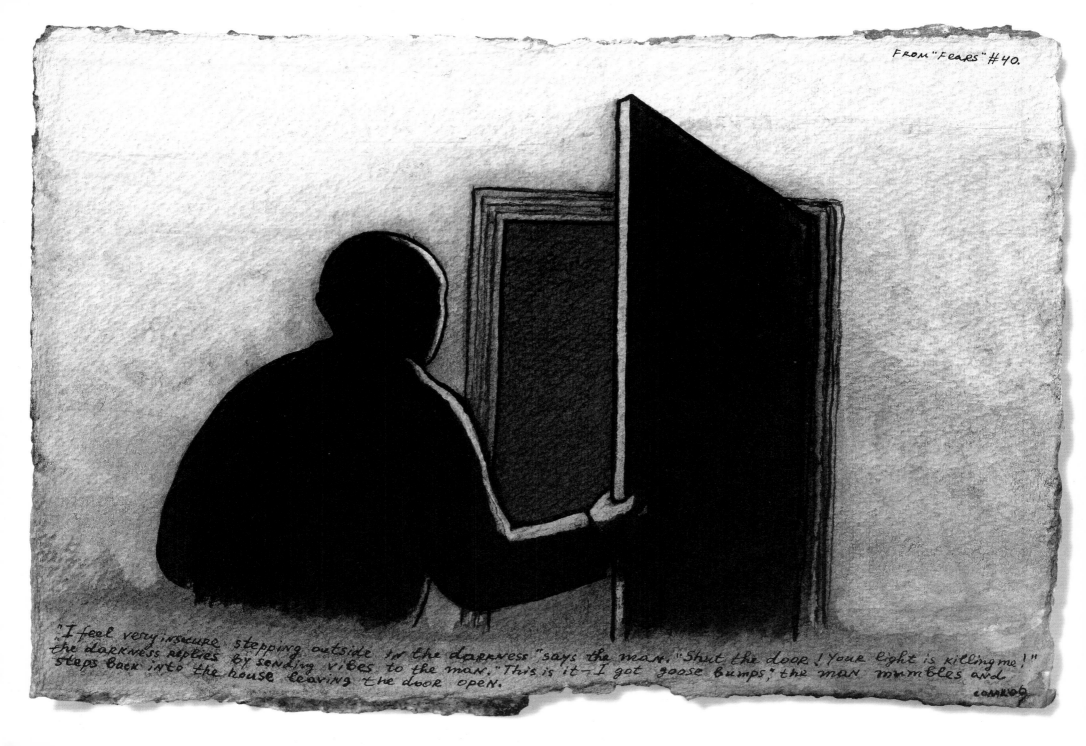

FROM "FEARS" #40.

"I feel very insecure stepping outside in the darkness," says the man. "Shut the door! Your light is killing me!" the darkness replies by sending vibes to the man. "This is it — I got goose bumps," the man mumbles and steps back into the house leaving the door open.

conrad

#41

This drawing has a number 41. She is scared of losing her European identity because of that # sign.
Luckily she still has "1" written in that way (not like a stick "1"). However she has to be on her own for awhile.
maybe later she will pop up on this sheet of paper.

OPAK '06

A miserable insect is reclining on a kitchen floor waiting for somebody to smash her. Only 3 of her tentacles feel a bit of fear. The other 16 are okay — their life/death concept is different.

CRAK '06

A president of a Super Power just saw a hidden weapon for mass destruction (overseas, of course). How did he manage to do that (none of the others saw anything)? He was on the highest possible position, that is the answer. And he gets a lot of money for being there and seeing things the others can't see. One of his subjects (sorry, conak of citizens) is afraid of being I better stop now.

A big city house is not afraid of the pollution. Her own smoke on the other hand, is pretty scared to go out and immediately disappear in that thick and stinking smog. What about the house's inhabitants? There aren't any.

CORAK'06

A little, very tiny, animal is staying on the path of a brave knight going back home after the latest crusade.
Why? Because the animal has this feeling that it may be good to accept Christianity, and that this big
fella with shiny armour would help him in it. Unfortunately the knight is preoccupied with his own
bitter thoughts (namely-how will he find his wife after all these years, did she behave, and so on) so he
will not see the ready-to-be-baptised animal and his horse will smash his head with a great
pleasure because the horse doesn't like other animals talking to
his master. The good thing is that right now the little animal
has no fear of the oncoming couple.

CONOR '06

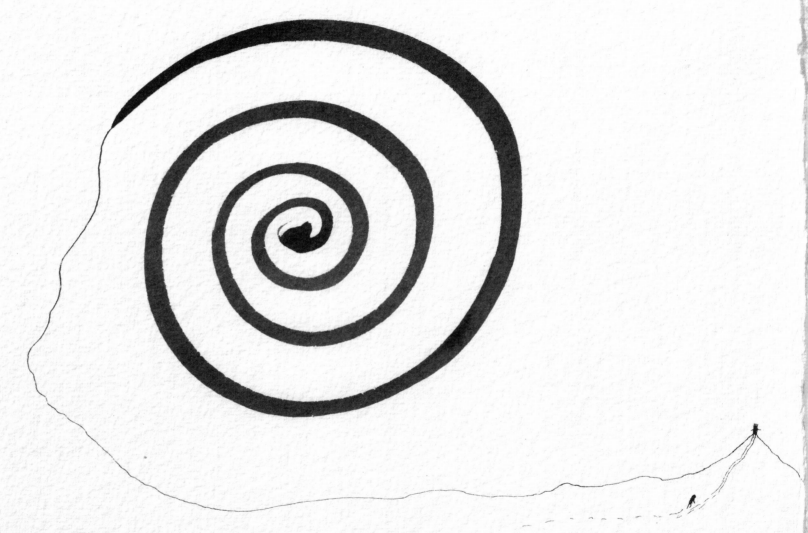

An exhausted messenger is delivering a bad news to the king of a medium-size kingdom. The message: due to that enormous, giant space springs (that has been staying calm above in the sky for 45 years) recent activity, after a few hours, the kingdom will disappear. Usually the bad news messenger gets killed, but now the currier is so exhausted that he can hardly feel ANY FEAR of the king's royal anger.

OLAK'06

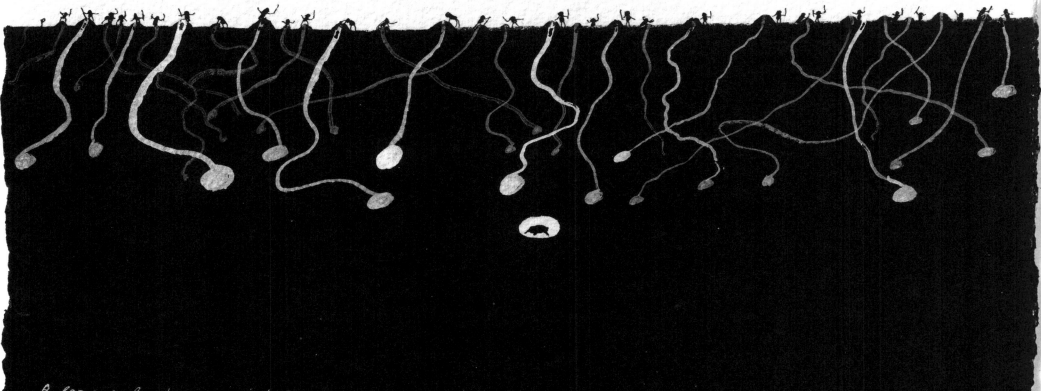

A lazy mole has a good luck too. However, all her siblings (and 11 uncles) are in big trouble right now. "I'm not afraid to be lazy" the mole says to herself and rolls over to her other side down there, in her comfortable burrow. CONRAD '06

A dick-like free-lance shape applied to the local granting-permissions-for-mingling-with-pedestrians commission for a certificate to work infront of a big shopping mall. The commission didn't dare place him in a busy area like this one, since half of its membership feared the public protesting against his suggestive looks whereas the other half wanted out of this sticky business altogether. The shape wound up hanging out in the area anyway (the mafia was in control of that commission, so everything was okay).

LAAK '06

A MAN is fearful of becoming a proper citizen of any country. That's why he spends his life by walking along the borderlines of various states. He feels safer that way.

27.12.06 ON the EVE of Bulgaria's joining the EU
COLAKIOG

Today is my birthday. Now I'm 49. I still have most of my fears that have been with me over the years. That's why the thumbs-up-for-good-luck-to-my-beloved-people position of my hands. However, some old fears seem to have disappead. For example, when I was young I had that fear that my penis was too small. Nowadays, when my CV is really huge, that particular fear's vanished.

28.12. LOAK'06

Somewhere ahead there is a hungry shark. To get properly scared you have to imagine that you are under water. CONAX '06

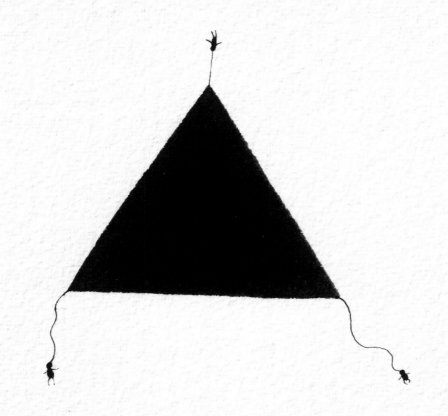

There is this magic black triangle that can make you feel brave and fearless. How does it work? The person who needs
treatment gets connected to either of the three corners of the magic triangle and after 17 minutes the session is over and
we have a brand new, brave & fearless person. Sometimes it is possible, if the treatment is longer than 17 minutes, that
the hooked up person becomes overbrave & over fearless (see the one on the top). In such cases,
an extra charge applies which is not conak'06
that much.

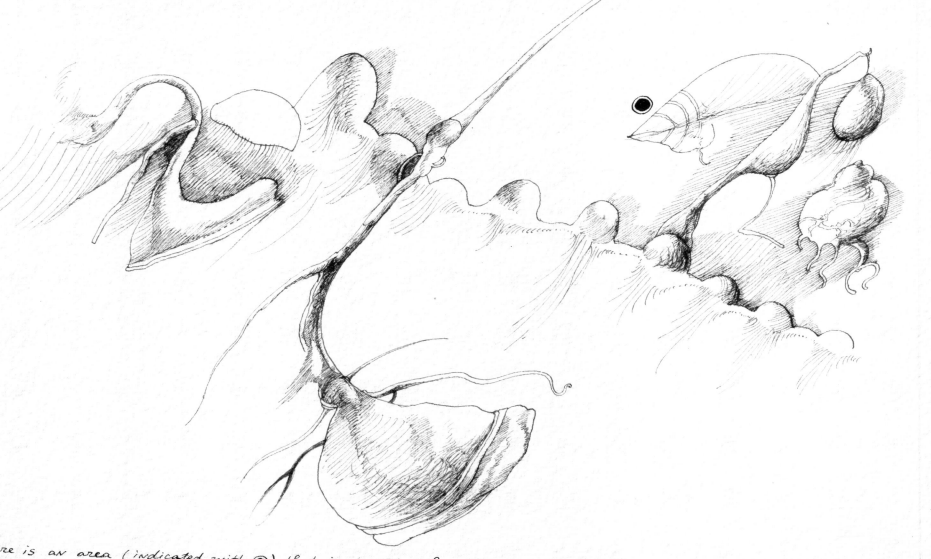

There is an area (indicated with ⊙) that is scary of having a too-abstract look and, as you can see, it is trying to immitate recognisable things.

CONAK'06

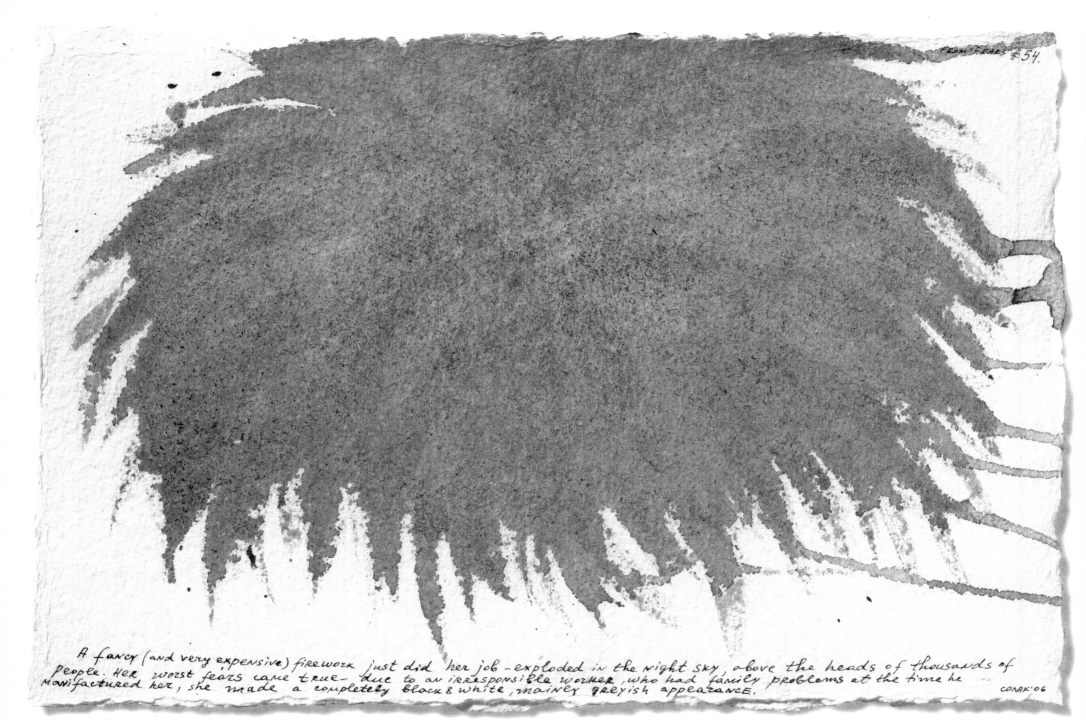

FROM "FEARS" #54.

A fancy (and very expensive) firework just did her job - exploded in the night sky, above the heads of thousands of people. Her worst fears came true - due to an irresponsible worker, who had family problems at the time he manifactured her, she made a completely black & white, mainly greyish appearance.

CONRAD'06

*The First day of the muslim's EID which starts for the Sunni (the dictator's people)
today and for the Shiite (the good guys "dancing around his body")
tomorrow.
P.S. It seems that during his execution, the dictator hasn't shown
any fear which is a really bad news for democracy.

This morning a dictator was executed by some of his compatriots. They say he had a fair trial and he was sentenced
to death for possesing weapons of mass destruction which... er... er... sorry, they got him for another thing which
I can't remember. It seems today is a day for celebration as one of the Iraqi people's fears is gone.
The other one, the fear of Americans, is still there which is kind of nice.

30.12.06* COLAK '06

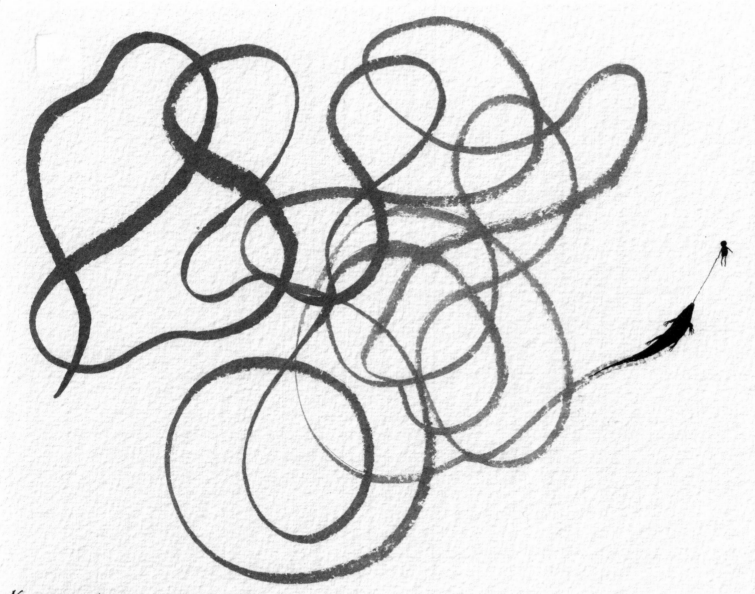

Now a man has a pet – a still bleeding crocodile. The man is very happy: he's overcoming his life-long fear of predators.

COLAK '06

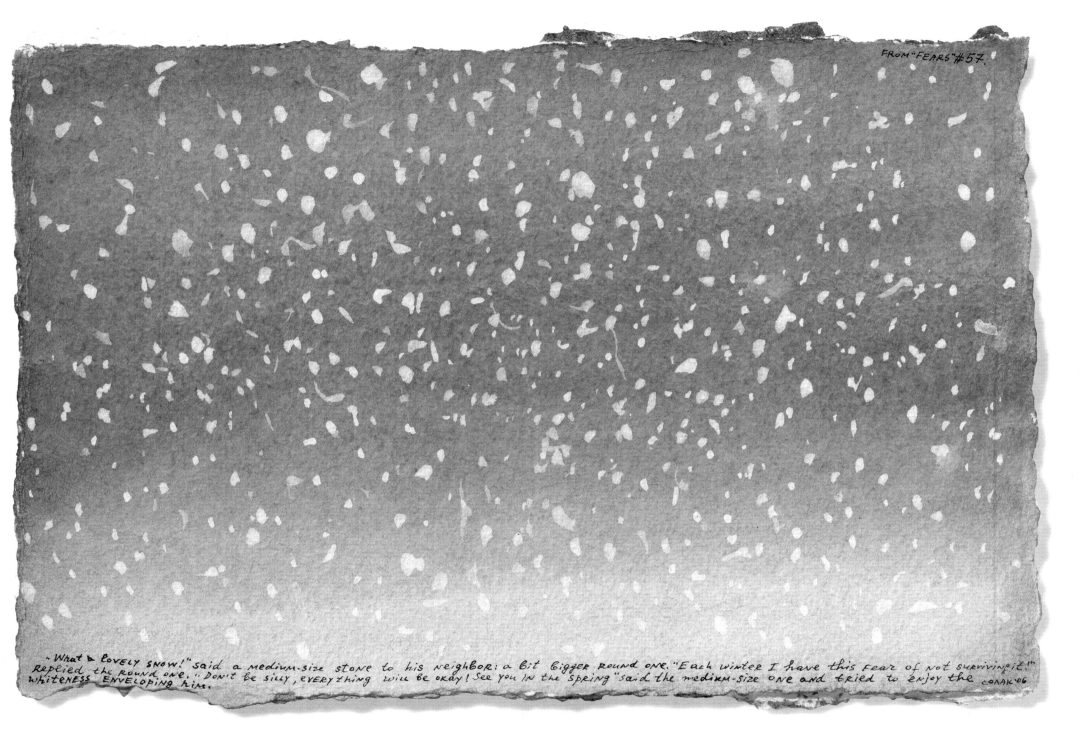

FROM "FEARS" #57.

"What a lovely snow!" said a medium-size stone to his neighbor; a bit bigger round one. "Each winter I have this fear of not surviving it!" replied the round one. "Don't be silly, everything will be okay! See you in the spring" said the medium-size one and tried to enjoy the whiteness enveloping him.

CONAK '06

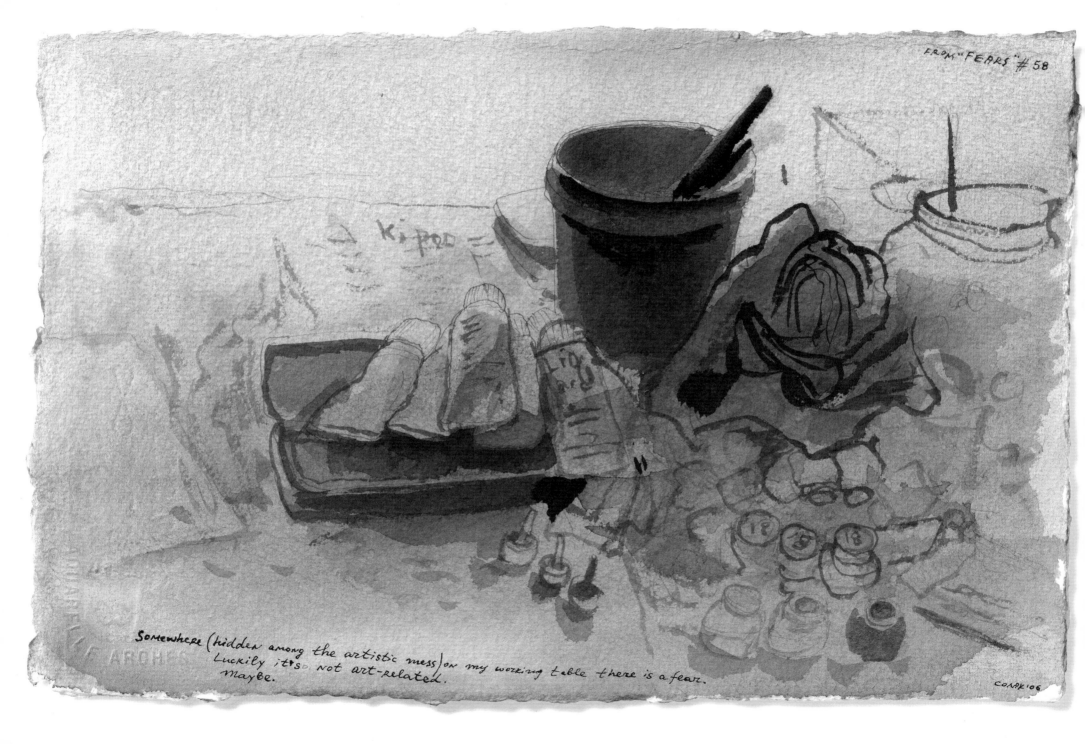

Somewhere (hidden among the artistic mess) on my working table there is a fear. Luckily it's not art-related. Maybe.

CONAK '06

A MAN FROM a big city is jumping like an ape: trying to recall his predecessors' psyche. They had no fears of the kind the man has. Of course, they got spooked occasionally, but after the horror was over, they immediately erased it from their heads. "Why did I develop in such a direction?" the man worries while getting really tired of that jumping.

LORAK '06

After a long suffering a poor country is finally on its way out of that bloody dark tunnel. Here is the light at the end of a tortuous journey. Actually there are two lights which is really confusing. The poor country has no other choice but wait until one of them fades.

FROM "FEARS" # 60. CONAK '06

I have no fears (temporarily). only one but it shines for seven.

0.13 a.m. 1.1.07 CONAK '07

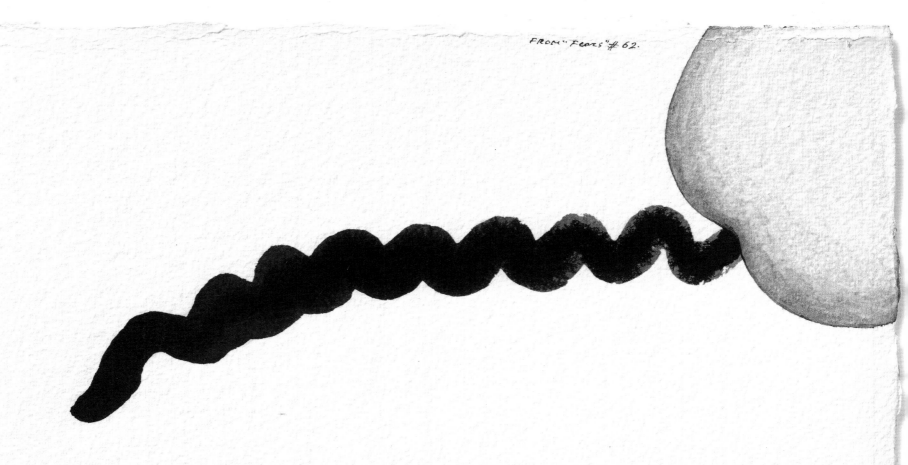

A piece of shit just got released. "What a wonderful world! I'm so happy!" the shit became very excited.
That world, by the WAY, was full of fears but, fortunately, none of them was able to scare
our piece of shit. The mood in the whole story was so optimistic that a writer made a script out of it, with
a nice happy end.
CONAK'07

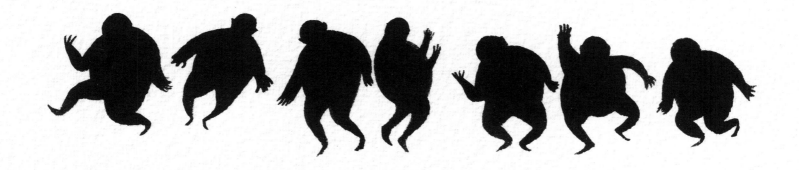

Seven very fat men are dancing vigorously. They are desperately trying to postpone death.

ÇOLAK '07

A cloud has this enormous fear of getting split by the wind. He is trying to concentrate and produce an inseparable core. Maybe he will succeed.

comak'07

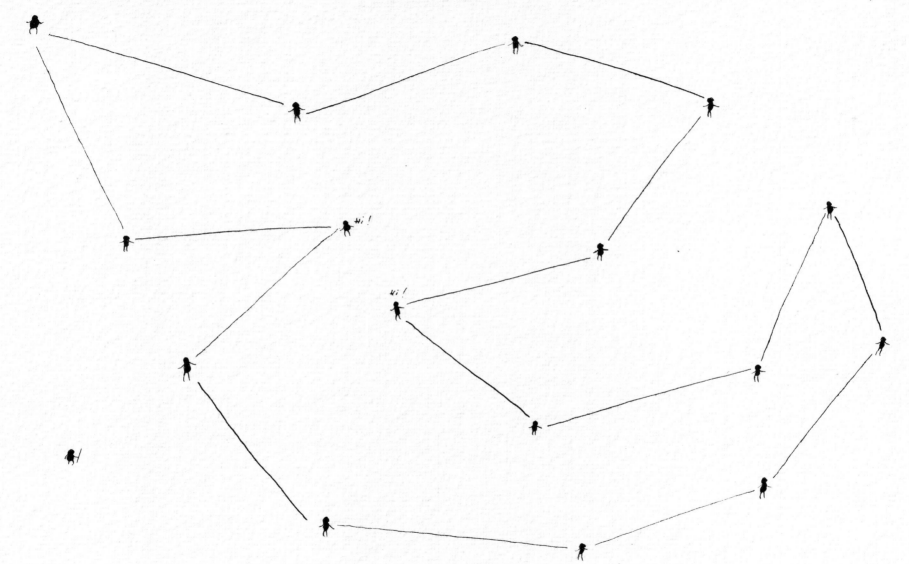

A small society with a well-organised structure is on its way to collapse: two of its members decided to have an illegal contact. "What shall I do to prevent the upcoming disaster?" the small society's superviser worries.

COLAK'07

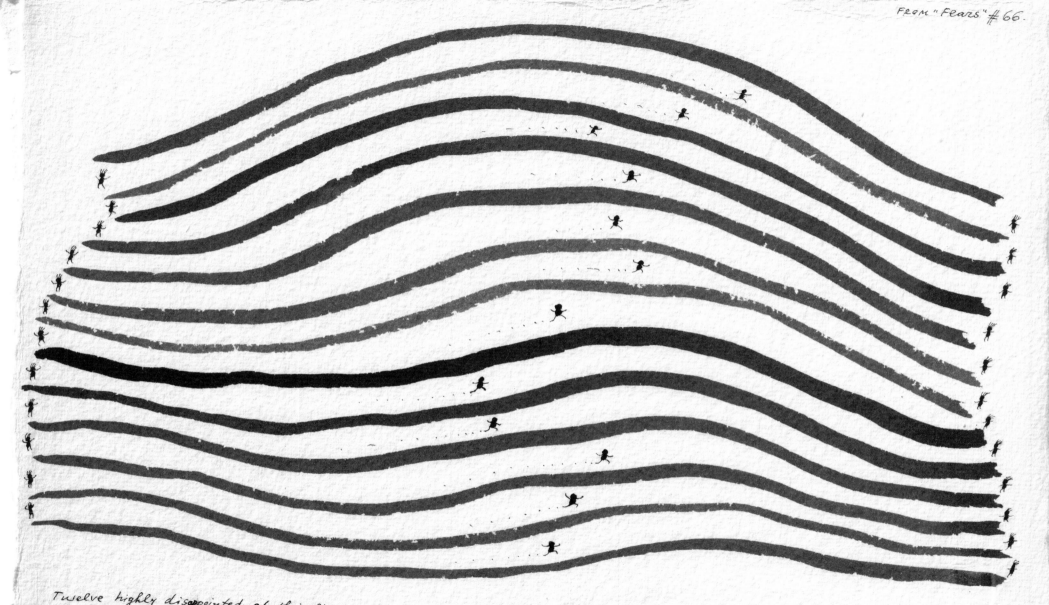

Twelve highly disappointed of their lives men are running from their present wives to meet (and eventually marry) their future wives. 3 of them are still having some fears that something might go wrong.

COLOR '07

A sleeping volcano will wake up in a few minutes. There is this beautiful town which will be destroyed. only one of its citizens is smart enough to leave the town before the erruption (why smart? - he had actually read this very text).

CONAK '07

A brave (and curious) snail and his (scared) big brother.

COOK '07

"6" and "9" decide to check what's the fuss about that 69. "9" is a bit scared though, as you can see.

COLAK '07.

A mighty devil is listening to the problems of a little sinner. It seems that the devil will help the little sinner solve his problems. However, he wants something in return — one of the little sinner's daily fears. The devil is curious what the feeling of having a fear is like. cornwov

All of her fears suddenly went away. "FROM NOW ON, I'll stay with my eyes closed," she said to herself and almost immediately got the desire to open them.

cona '07

A fisherman experienced something extraordinary. apparently the fishing line was extremely sensitive to the fear of the little worm at the end of it and the line registered that fear in an unbelievable way. "What a day!?" the fisherman said to himself and opened the steel box with artificial flies.

conrad '07

A big planet with a very hard core doesn't want to let fall a tiny satellite planet. "It sounds ridiculous, I know, but I'm really scared to be on my own. I need you" the big planet is trying to convince the tiny one while keeping her on a leash (made by small asteroids).

Conak '07

A pale spermatozoid is heading North. He prefers south for there is a nice sun beam sneaking through the clouds. Unfortunately, he is not the decision-maker. Everything is in the hands of his jerking master who happens to be afraid of seeing direct sun-light while trying to keep the image of his sexy neighbor in his head.

cmak'07

A MAN IN 10 parts — 1 head, 1 torso, 2 arms, 2 legs, 2 ears, 1 nose and 1 penis. IN only one of these parts there is a substantial quantity of various fears. good for the other nine.

COLAK'07

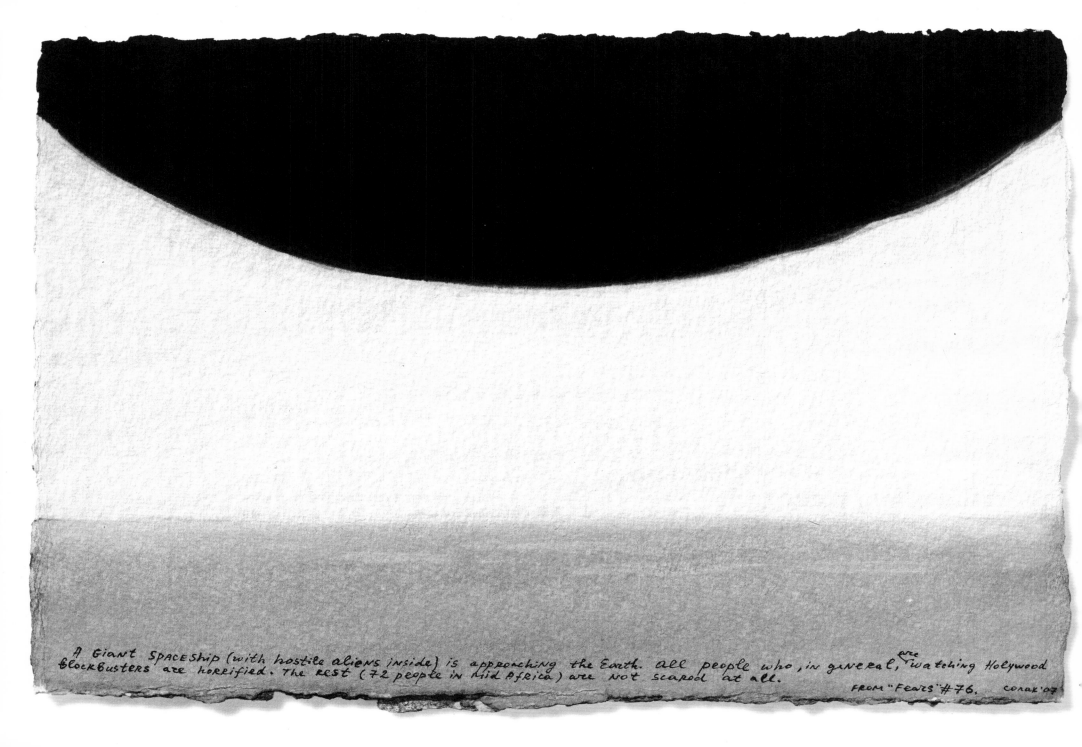

A GIANT SPACESHIP (with hostile aliens inside) is approaching the Earth. All people who, in general, are watching Holywood Blockbusters are horrified. The rest (72 people in Mid Africa) are not scared at all.

FROM "FEARS" #76. CORAK '07

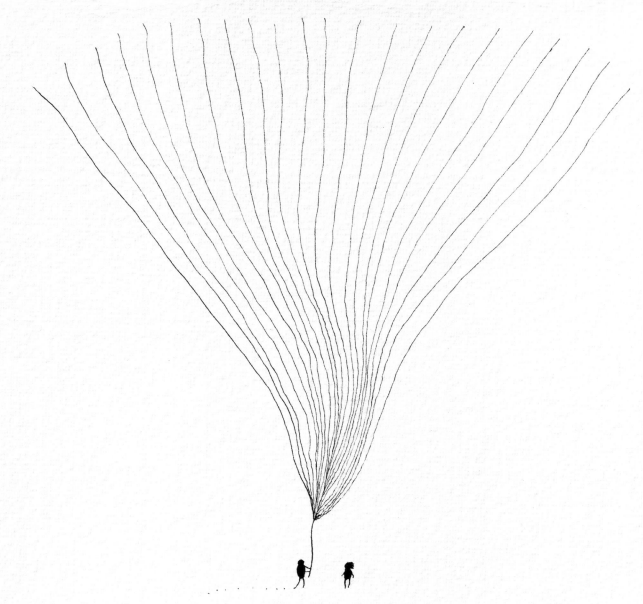

A husband is giving his wife a huge flower. HER fear: it seems that this time he did (apparently secretly)
a really bad thing.

corax '07.

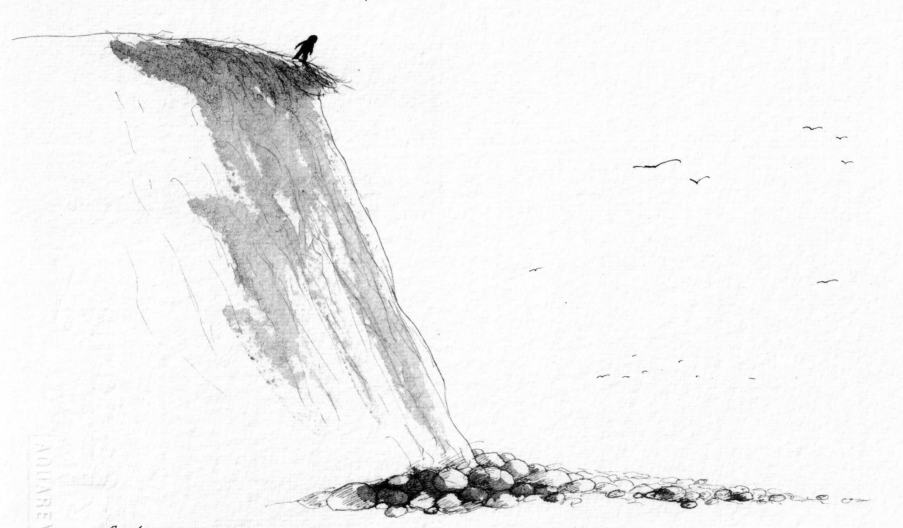

A desperate man wants to commit suicide by jumping from a cliff. Here comes an unexpected obstacle – there is no water down there, only stones, very hard and ominiously looking stones.

corak '07

"MUM, I'm really scared working at night, it's so dark!" the baby-lightning was talking to its mother.
"Don't worry, dearest! Humans are more scared than you" replied the mother-lightning.

CONAK'07.

researchers

a supervisor (for the friendly aura)

a device for measuring
the level of stupidity
of the whole
situation

a friendly aura

a container
with 34 nice things

a mean aura

a supervisor (for the mean aura)

a container with 34 fears

an independent observer
(a part-time mafioso)

a lot of cash

An attempt to spent a lot of cash for a research on the influence of a fears & nice things combination on the lives of 2 average people.

CONAX '07

A general fear

COLAK '07.

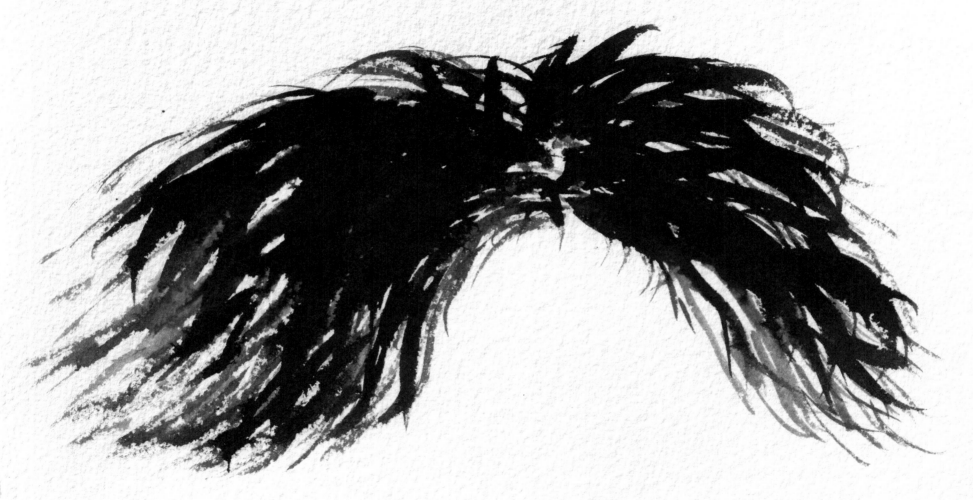

The hair of a hardrock musician wants to change its owner. The band he is playing in is pretty mediocre (he is mediocre as well), so the musician will most probably move in another direction e.g. hip-hop. Here comes the hair's fear that it'll be shaved clean. She better change the head in advance (going to a retired hippie for example).

CONK '07

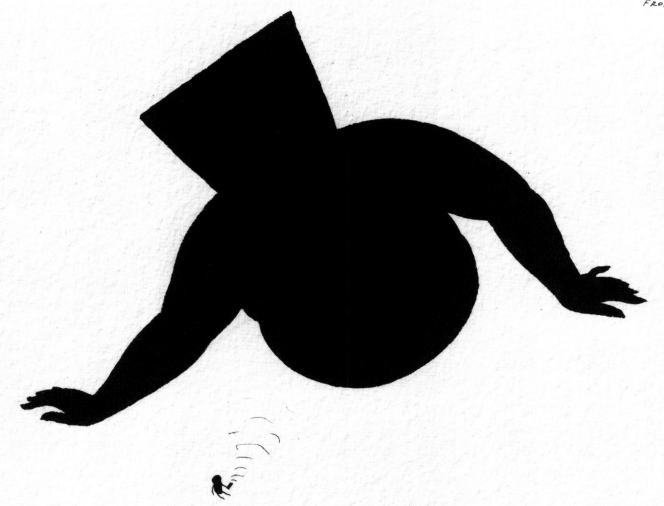

A little spoiled boy received a wonderful present for his birthday. His rich (also spoiled) parents bought him a brand new, state-of-the-art giant with a remote control. The boy enjoyed the toy, so far, by replacing the giant's head with a geometrical object, taking away the giant's lower part, making his left side gay and some other, not-so-visible things. "This is too much!" said the giant's right hand. "I'd better smash his head or the remote or something," the hand was hesitating.

YES NO

Both of them are equally frightened of each other. That's why the smart people use "maybe".

COMK '07

P.S. This was supposed to be a politically correct story, but something went wrong.

FROM "FEARS" # 85.

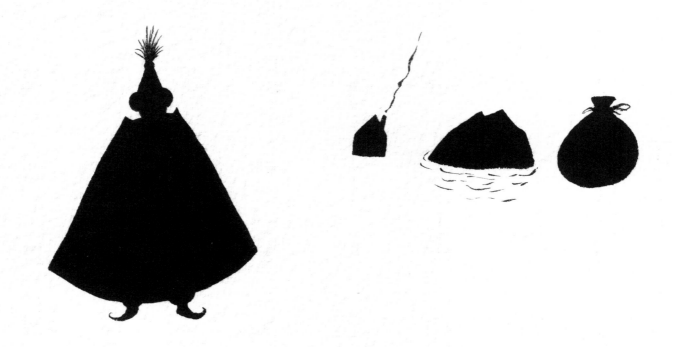

A Magician from the East has just been recruited by a powerful terrorist cell (they appreciated his cloak as being very useful in hiding explosives). As an inception job he is offered to blow up one of the following: an ordinary home inhabited by an average family; a giant iceberg which will consequently flood N.Y. or a huge money load that will tilt the world economy off balance. "Can I do something else?" asks the magician. "Yes, you can, but it needs to be rational" is the answer. "I'm afraid my idea is a bit irrational. I'd like to blow up my neighbour" the magician says.

CORAK '07

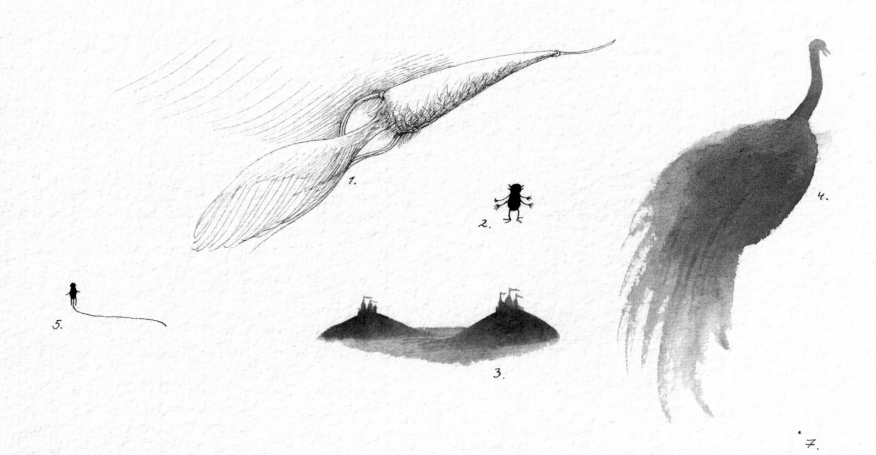

1.

2.

3.

4.

5.

6.

7.

#1 (a useless shape); #2 (a weirdo with 4 arms, 4 feet, 4 ears and 3 tongues); #3 (twin castles with all furniture inside mirrored between them); #4 (a 250kg bird); #5 (a man with a long p.); #6 (the new number called "seyt"); #7 (a speck of space dust); so what do they have in common? A fear of being ordinary.

colak'07

I did a bad thing again. And again — my bad conscience on top of me. She feels really well: having my fear for breakfast, lunch and dinner.

COLAK'07

A man is really scared of crossing a torren water (yet he has to). All his day-to-day life disappears. Only this problem stays in sight.

COLAK '07

A man has a fear of WORKING. Here he is - relaxed, with no worries whatsoever.

colak '07

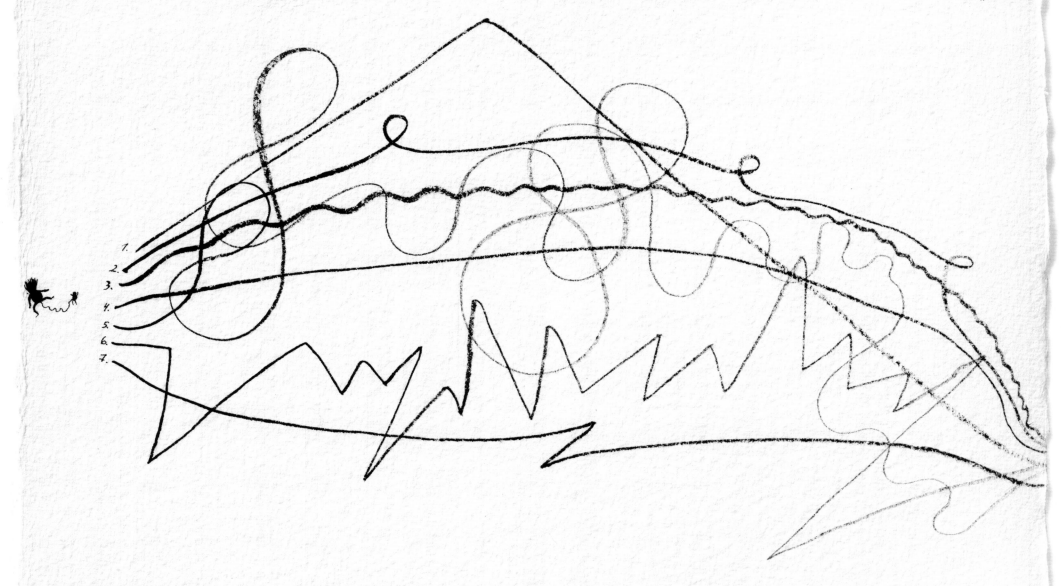

1.
2.
3.
4.
5.
6.
7.

A NEWLY-BORN baby was given 7 life options, all relatively secure. The baby has no fears of any kind yet, so it would like to try another, eighth option.

corak '07

A giant beast is doing his best to horrify a sleeping man. the man is convinced that he is having again a nightmare, that the beast is in his head. The beast gets really pissed.

colak '07

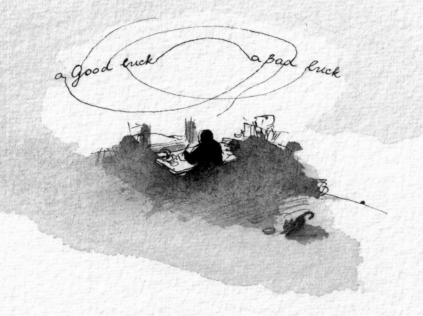

a good luck a bad luck

A philosopher is writing a very important essay about the relation between good and bad luck. At the same time
a little mouse is afraid of leaving its hole because of the philosopher's cats hanging around. "It will be a really good
one!" the philosopher is thrilled.

CONK'07

I just read the story of (another) ill child. I cried.
IN the Next days, when I'm going to pay a stack of money to the Bulgarian tax authorities (for feeding a corrupt administration & arrogant politicians), I will also give (unfortunately not so much) money to this child.
For sure the corrupt administration & the arrogant politicians will not do such a thing, which doesn't necessarily mean that I'm a nicer person.

17.1. CORAK '07

DEMOCRACY

DURING
DEMOCRACY. socialism (when I was young) I had less fears than now (when I'm older), living in a

COMAK'07

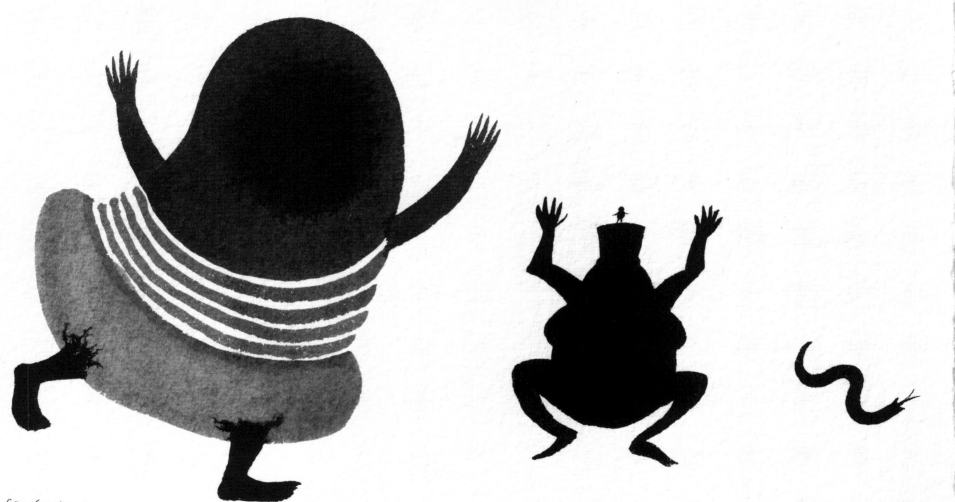

Centuries ago, somewhere in the prehistoric bush, a peculiar scene took place. A tiny fellow landed out of the blue onto the crown of a local mother-queen. The queen's personal magician has tried his best to move the tiny fellow into another living creature (a deadly viper). Unsuccessfully though, because the fellow had no fears of local magicians for he was coming from the future (year 2007).

Thirteen pairs (26 people) have a fear of communicating. They are trying to solve the problem. However, there is one couple which doesn't believe that this is a problem at all. The others are quite jealous.

corak '07

A lonely man

COLAK '07

A tiny piece of something is floating around. It's happy – it has no fears, no emotions, no worries. only happiness in its body. "What a crap!" says a passing-by piece of Nothing.

COLAK '07

An End

Courage is resistance to fear, mastery of fear — not absence of fear.
Mark Twain, *Pudd'nhead Wilson's Calendar*, 1894

Courage
SUZAAN BOETTGER

With these incisive images, Nedko Solakov participates in the increasing tremors in daily consciousness and public discourse around the issue of fear. Often, he gives the hero of these psychological adventures a rotund head and figural heft resembling his own shape. This, combined with the captions' first-person perspective, suggests the autobiographical basis of these witty drawings. Yet their emotional realism is tempered by the seductiveness of fantasy. And in his visual and verbal play Solakov reaches far enough into himself that many of the ninety-nine *Fears* touch a bedrock of shared feeling. The historical context of contemporary society in which they were produced gives their wry narratives a resonance far beyond the personal. Deceptively formatted as illustrated fables, these adroit ink drawings and astute observations display the artist's attunement not only to his own inner vibrations but to the wider resonances of global anxiety.

Solakov is regularly described as the most famous Bulgarian artist since Christo (who anyway left the country in 1956, at age twenty-one). Born in 1957, he grew up in the city of Gabrovo and attended Sofia's Academy of Fine Arts. Except for postgraduate work in Antwerp in 1985–86 (at a time when in Bulgaria he was already an established young artist) or later in various international stints as a visiting artist, the Bulgarian capital has remained his home base. His installations of images and texts, frequently handwritten directly on the wall like street graffiti, have been so inventive, so transgressive in both procedure and subject matter, and so resistant to commodification, that he is casually termed a 'conceptual' artist — the catch-all term often applied to those who don't make discrete, portable (saleable) *objets d'art* and whose work no other niche quite encompasses.

However, Solakov's creative process, while rigorously thought-out, seems to originate more in emotional receptivity, in what he has described as 'my "immediate reaction of assessment." I know that without this "way I feel it" nothing will happen.'[1] His style is actually expressionist, both in its introspective procedure and its bold, gestural visuality. The addition of ironic self-deprecation often leavens the self-absorption. For example, in drawing #7 a 'chubby' jellyfish has a fear, contradicting its sea-born identity, of deep waters. That, and embarrassment over its size, causes the rotund creature to be apprehensive about accidentally 'touch[ing] swimming ladies with big breasts.' Fears of oceans, girth and inappropriate sexuality humorously coalesce. This same charming synthesis of sweetness and saltiness can be found in Solakov's expansive mixed media installations of script, drawings and assemblage, which have been exhibited from Oslo to Ohio.

When our actions do not, / Our fears do make us traitors
Shakespeare, *Macbeth*, c. 1603

SOLAKOV'S PREVIOUS WORK
It is easy to see Solakov's intense involvement in imaging fears as a way of managing his own ongoing subjectivities — 'the way he feels it.' An early work, the notorious construction *Top Secret* (1990), cues us into a specific social source of Solakov's history of fear. A cross between a diary and a business document file, the small wooden index-card cabinet contains drawings, objects and handwritten texts describing his youthful collaboration, beginning in 1976 as an eighteen-year-old second-year art student and ending in the summer of 1983, as an unpaid informer for the Bulgarian secret police.[2] After *Top Secret*'s first exhibition in a group show ('The End of Quotation', 1990, at Sofia's Club of the Young Artists), so much misunderstanding and rumour surrounded this episode that Solakov published an explanatory story about his activities in the weekly *Kultura* newspaper. (For the work's reprise at the 2007 international exhibition Documenta 12 in Kassel, Germany, he added a forty-minute video in which he read the entire contents of all 179 slips from the chest.) Ascribing his initial spying activity to the naiveté of a young man believing in socialism and eager

to be patriotic, he told of his growing discomfort, as a professional artist, husband and father, with his co-option by the State. So, for his public revelation, he explained,

> He drew and described, using Pop art means, everything shameful and depressing which was still creeping around his ever more hurting heart. The man exhibited in public this card index chest and accepted internally once and for all that only he or she who can overcome his or her fears can be a true artist. It doesn't matter what kind of fear this may be – the fear of changing the direction of one's work in spite of the success it is gathering, or the fear of revealing oneself to the full at any cost and thus accomplishing an artistic act. [3]

Just a few months earlier, soon after the 1989 collapse of communism, Solakov publicly separated himself from the former tyrannical State by making it into a foil for satire. He had been making works critical of the system since 1986, most of them not exhibited; this one was prominently visible. Turning the tables on its surveillance of citizens, his *View to the West* (1989) installed a telescope on the terrace of the Artists' Union. Its westward perspective focused on the red star still crowning the Bulgarian Communist Party's headquarters, which was dismantled soon after, both moves manifesting the country's post-communist disorientation.

The political reformation was also background for an installation presented at the 1992 Istanbul Biennial that brought him international attention. His *New Noah's Ark* splayed across the floor ninety-six fantasy creatures made of thermoplastic and metal, along with drawings and paintings in a hand-made book that included drawings by his children. In the accompanying narrative 'a common man' became the new Noah, whose 'world was doomed (that's what those from the "elsewhere" told him).' The disordered display, and the evocation of a community of 'creatures' who 'had come from another world (already gone)' and were embarking on a journey of transformation, captured what Solakov later described as 'the general uncertainty in my country, in my world's future' as it evolved from 'collapsed socialism' to capitalism. [4] In envisioning a *New Noah's Ark*, his art encouraged awareness of the sea-change the region was undergoing.

The experience of rigid authority could also underlie Solakov's dramatic installation / action / performance piece for the 2001 Venice Biennale, *A Life (Black & White)* (1998–2001). In a large, high-ceilinged gallery, two men hired for the occasion continuously painted the walls while viewers strolled through. Daily for the five months of the Biennale, one proceeded around the gallery covering the walls in white, while across the room the other followed, rolling on black. His most materially minimalist piece – for an artist who seems to continually spew forth inventive drawings and self-reflexive commentary – it has a reductive, self-cancelling duality that resonates with many polarities, from absolute positions of yes and no to the extremes of night and day, without the growth or subtlety that transitional shades between them would imply. The reductive Manichaean thinking fatalistically enacts the arbitrariness of tyrannical absolutism and the pointlessness of personal endeavour. It also could be taken as a joke on the triadic procedure of dialectical materialism – thesis, antithesis, but no synthesis or progress. These oppositions appear in the *Fears* series in #84: 'Yes and No are equally frightened of each other. That's why the smart people use "maybe".'

Several images in Solakov's *Fears* addressing an imbalance of power in social relations evoke the repressive milieu in which he grew up, such as #65, with its description of an 'illegal contact' appearing to allude to authoritarian institutional restrictions on travel and contacts with foreigners. Some of these could as well apply to disparities within capitalism between corporate and individual domains, such as #44, with the chimney smoke afraid of being absorbed by amorphous, destructive environmental forces such as pollution. In #45, a small animal is powerless in relation to a large knight and his mount, but roles are inverted in #68, showing 'A brave (and curious) snail and his (scared) big brother' – perhaps another jab at the 'Big Brother' role of state-sponsored surveillance. [5]

In the mid-1990s, as communism's presence receded and Solakov's participation in the international art circuit increased, he turned his playful skepticism of authority toward a more fashionable subject in the West: sources of legitimacy in the art world, including museums, gallery spaces, curators and collectors. In gentle fantasy fables of texts and drawings written on museum walls, and in assemblage installations, Solakov addressed conditions of the status and commerce of the art object, and the artist's striving for attention. *The Collector of Art (Somewhere in Africa there is a great black man collecting art from Europe and America, buying his Picasso for 23 coconuts and his early Rauschenberg for 7 antelope bones...)* (Ludwig Museum, Budapest, 1994) inverted early twentieth-century artists' appreciation for African tribal carved masks and statues with a tale of a tribesman's craving to decorate his thatched hut (created for the installation) with twentieth-century art from the museum's collection by Pablo Picasso, George Baselitz and Joseph Beuys (all appreciators of forms or materials that in the past were construed as 'primitive'). *Mr. Curator, please . . .* (Künstlerhaus Bethanien, Berlin, 1995) projected current artists' competitive moves onto historical greats, as a hypothetical curator is beseeched by the ghosts of Old Masters such as Bruegel, Leonardo, Michelangelo and Rubens to be the one picked for a prize. Solakov's casual handwriting on the wall narrated the story, and the curator's desktop reproductions and paperwork displayed his conflicted state of mind. Another fairy tale with a putatively subversive stance toward his host museum, *The Thief of Art* (Arken Museum of Modern Art, Ishøj, Denmark, 1996) actually confirms the power of a museum's collection by demonstrating how a passion for art can overtake anyone. 'Bigfoot', a legendary hairy primate with a chubby shape similar to Solakov's,

> was reclining on the floor of his cave, contemplating the veiled mountains outside. And then, there appeared an enormous desire to go and find beauty, a piece of beauty, which should not be beautiful by its nature. He got the extremely strong feeling that maybe somewhere there

are things which are the real beauty. And they were made by people who suffered and died because of these things, immuring the last thoughts of their lives into these things. They called them works of art.

A piece of art? That is maybe what I need.[6]

With Solakov's clear belief in the beneficial effects of art, it's not surprising that throughout his career he has directly addressed his fears through art-making as an act of control and exorcism, in a quest for confident well-being. His earliest work addressing this theme, *My Fears* (1989), is a painting comprised of nine adjoining stretched canvases that together identify thirteen fears. They address the basics: death, blindness, a car crash and a plane crash, being poisoned or mugged, ozone depletion, a house fire, lightning, etc. He describes himself as superstitious, even doing a work on that theme (*The Superstitious Man*, 1994) and has noted that 'each morning when I enter the studio I go through all numbers on that painting with a fist with thumb up for good luck to my beloved people.'[7] In *Fear* (2002–03) he confronted his terror of flying by gripping raw terracotta clay in his fists during flights, and exhibited the shapes thus formed (some of which had fractured in the firing process).

Fair seedtime had my soul, and I grew up
Fostered alike by beauty and by fear.
William Wordsworth, *The Prelude*, 1798–1805

REPRESENTATION OF FEAR IN THE HISTORY OF ART
Solakov's *Fears* drawings are is his most extensive consideration of the topic, and he shows the world to be alive with fears. Occasionally they are fantastic, as in #64: 'A cloud has this enormous fear of getting split by the wind.' Some are innocuous, such as the fear of appearing 'different' from one's group (#53). They come in all sizes, the explosive blobs in #11 recalling the fairy tale's papa bear, mama bear and baby bear. Turning the focus directly on himself, fears are shown to turn up even on the artist's working table (#58).

In this, Solakov continues a lineage in the history of art that has seen eruptions of images of fear in particular historical phases. Occasions for corporeal harm have always been with us – wild animals or out-of-control vehicles; a bully on a desolate road; the proliferation of infectious diseases with unknown means of transmission or cure; raging fire, flash flood, or malefic drought; not to mention tyrants of state or hearth. Yet if one looks at art historically and considers fear, as neuroscientists do, a 'prospect-based emotion' deeply connected to uncertainty and the future,[8] then it's easy to see that eras of economic turmoil, public health threats and political disorder have particularly stimulated fearful images.

Cultural artifacts from European early Christian and Medieval periods (what the Renaissance repudiated as 'the Dark Ages') displayed the most widespread fear, caused by regular sieges of economic volatility, plague pandemics and ensuing 'witch crazes and possession panics, [provoking] a limitless fear of the devil present everywhere.'[9] This context induced the most copious pictures of fear, manifested in the prominent liturgical and visual theme of the *Last Judgment*. During the Romanesque period, a stern Christ centered between, on his right, orderly rows of the saved and, on his left ('sinister') side, the jumble of grotesquely degenerating damned, was commonly carved on church tympani to warn those passing by or about to enter, who would look up to see the condemneds' writhing nakedness and terrified expressions. In his Late Gothic frescoes for the Scrovegni Chapel in Padua, Giotto moved that drama inside the west wall to be viewed before exiting and painted a sinner-gobbling Satan amid the lower lurid conflagration.

The rationality and confidence of Renaissance Humanism, particularly in Italy, and the growth of urban affluence considerably diminished attention to the afterlife. Exceptional, then, are Luca Signorelli's huge yet graceful *Last Judgment* (c. 1500) at Orvieto and the vast and vastly harsher turmoil in Michelangelo's depiction of the same subject just a few decades later as the replacement altar-

piece for the Sistine Chapel (1536–41).[10] Michelangelo's brooding figural melee intensely evokes the new climate of fear, born of an instability that was both political – the Vatican's vulnerability to unruly forces within the Holy Roman Empire – and theological – in the Roman Catholic Church's quandaries in reaction to Martin Luther's accusations and the ensuing growth of Protestantism.

Solakov himself refers to 'Earth's Last Day' in his *New Noah's Ark* and the common desire for elevated salvation in his *Fears* #10. A man is depicted in 'heaven', a tiny, seated figure surveying the cosmos from the apex of a grassy hill, similar to the lone gentleman – or monk – who appears, often on promontories, taking in the immensity of the universe both in Chinese Literati ink paintings by Shen Zhou of the Ming Dynasty (c. 1500) and in early nineteenth-century German Romantic paintings by Caspar David Friedrich. But Solakov's protagonist can't let go of his familiar (thus, comfortable?) psychological identification with apprehension: 'It's kind of nice and calm although he still keeps his life-long fear of dying one day.'

As Polish-British sociologist Zygmunt Bauman writes, 'The experience of living in sixteenth-century Europe was crisply and famously summed up by Lucien Febvre in just four words: *peur toujours*, *peur partout* (fear always and everywhere). Modernity was to be the great leap forward: away from that fear and into a world free of blind and impermeable fate.'[11] In the nineteenth to mid-twentieth centuries, modernity's ideology of social and scientific progress conveyed great confidence in future improvements to urban environments and people's daily lives and life spans. Except for extraordinary periods such as wartime or sustained economic depression, society's faith in scientific progress brought rising rates of confidence in the world. As culture became secularized, fearful images became centered around violence by fellow men, particularly the military, as in Francisco de Goya's *The Third of May 1808* (1814), with its kneeling labourer in nocturnal Madrid, arms outstretched like a crucifixion, horrified by the line of French soldiers about to shoot him. In the early twentieth

century, Käthe Kollwitz's print cycles on the impact of the sixteenth-century German Peasant War and World War I on the poor contain darkly fearful images of hunger, rape and loss, whereas George Grosz depicted nocturnal urban menace in wartime Berlin. That Great War also inspired Ernst Ludwig Kirchner's *Self-Portrait as a Soldier* (1915), with his right arm imagined as a hand-less stump, both artistically and – with a scantily-clad model in the background – sexually castrated. Solakov's #23 relates, 'A young soldier is bravely marching on to meet the enemy. He feels no fear. He is a bit stupid, too.' Obviously, some fears are prophylactic necessities.

As personal obsessions became more overt subject matter in Expressionism and Surrealism, Edvard Munch's panic (*The Scream*, 1893), Giorgio de Chirico's imposing shadows on eerily vacant piazzas (*Mystery and Melancholy of the Street*, 1914) and Salvador Dali's anxieties of impotence (*The Persistence of Memory*, 1931) all depict a fear-laden world gone awry. After World War II, Alberto Giacometti's emaciated figures, grouped but isolated on a city square, describe Existentialism's estrangement from community. Adolph Gottlieb's *Burst* paintings invoke Cold War trepidations about the atomic bomb; Alberto Buri's burlap paintings call up blood and bandages; and Antoni Tàpies's gritty surfaces suggest architectural and corporeal scars. Anselm Kiefer and other German neo-Expressionists powerfully grapple with their country's experience of devastation, and Louise Bourgeois continues an obsession with darkly perverse sexuality. These are all predecessors to Solakov's exploration of fears, but in contrast to the extraordinary situations that stimulated these works, the subjects of his fears generally have a Pop art commonness. They reflect basic anxiety-producing challenges everyone faces: heights, (#16), flying (#20), the inevitability of dying (#81) and, pertaining to our time, the affliction of AIDS (#27), 'One of my biggest fears (sometimes – the biggest). And I am not really screwing around.' Rather than reflecting a twisted idiosyncrasy, these fears, experienced to varying intensities by everyone in periods of vulnerability, are universal.

Life is a dream in the night, a fear among fears,
A naked runner lost in a storm of spears.
Arthur Symons, *In the Wood of Finvara*, 1896

THE LARGE NUMBER OF FEARS IN THIS SERIES

And yet, another clue to understanding this collection of images is their very number. Ninety-nine is a large quantity of separate works in a hand-made series. This number presents a great investment in the topic of fear, perhaps even an obsession. Visually, the pages have considerable variation. In an overview scan across leaves, one notices how Solakov has varied the imagistic effects between white expanses and dark masses, from a density of drawing to sparse lines, and from veils of washes to graphic patterns. This technical facility with rendering skills and fluency with brushwork demonstrates the benefits of training at a traditional art academy.

Nevertheless, beyond this display of virtuosity, why ninety-nine? The number connotes, on the one hand, an unfinished progression, less than the even hundred of a decimal system (in exams, a perfect score), calling to mind Bulgaria's position on the geographic and cultural margins of Europe and its former status as a minor satellite of the mother ship of the Soviet Union. But the number ninety-nine is also familiar from the marketplace, offering as it does the subliminal appeal of a bargain price, just slightly cheaper than a round number. The fact that the Fears series numbers ninety-nine drawings suggests the artist's desire for his work to appeal, like Pop art, to a wider audience than the art cognoscenti.

Although the *Fears* drawings are numerically sequenced, they need not be viewed/read in that order, because this series doesn't form a dramatic arc of a story of crisis and resolution. Some captions refer to previous drawings, but most image-and-text combinations are self-sufficient statements or fables. The series can be dipped into at any place at random, when fear strikes or otherwise, for a little wit and inspiration.

Counteracting all ninety-nine displays of the artist's sensitivity to vulnerabilities, the fortitude demonstrated by making ninety-nine illustrated stories of fears, and the wit of

aligning them with the marketplace, suggests both strength of character and shrewdness. As with theatre, we should not confuse the role with the actor, and the book *99 Fears* can also be considered Solakov's act of boldly bringing attention to himself, disarming us with his sweetly imaginative, self-deprecatory manner. Even when the sentiment of a particular drawing is acerbic or the mood morose, overall the wit and energy manifested in this project suggest that a fundamental resiliency undergirds Solakov's attention to fearfulness.

Ours is, again, a time of fears.[12]
Zygmunt Bauman, *Liquid Fear*, 2006

OUR HISTORICAL CONTEXT

Yet the most salient meaning suggested by the large number of pages in Solakov's *99 Fears* is its reflection of fear's prevalence in current social consciousness. His extended engagement with fear serves to illustrate Bauman's claim that in our historical moment, 'Occasions to be afraid are one of the few things of which our times, badly missing certainty, security and safety, are not short.'[13] In marked contrast to the post-World War II optimistic exuberance that produced spectacles of consumerism first in the United States and then in Europe and Asia, and the great hopes accompanying the collapse of communist regimes in central and eastern Europe in the late 1980s, in our century so far the operative word in international political discourse is 'terror.' The dramatic audacity and enormous destructiveness of the September 11 terrorist attacks in New York City and Washington, D.C., the subsequent bombs on subway systems in Madrid and London, the military aggression on the part of the United States – with international participation – in a still inconclusive war in Iraq, the continuing religious zealotry from all sides, and the expanding onslaughts of suicide bombers have resulted in the sense that risk is no longer just a matter of fear for individual safety. Urban terrorism is so plausible that the level of public danger is now governmentally rated, colour-coded from green to red, and broadcast.

The fear of terrorist acts has become such a part of life in many places in the world that, as Ukranian / American sociologist Vladimir Shlapentokh has noted, there is a concomitant 'growing literature on this issue.'[14] Susan Faludi's *The Terror Dream* observes a post 9/11 shift in gender roles, reinforced by media simplifications, back to traditional polarizations of heroic male and helpless female, her domain a retreat to the familial and domestic.[15] In Solakov's hands, the savior has become a (male) 'Magician from the east recruited by a powerful terrorist cell' (#85) but one who, instead of performing the requested massive destruction, only wants to engage in the petty act of blowing up his neighbour. The artist self-consciously notes at the top of the page, 'P.S. This was supposed to be politically correct but something went wrong.'

In the self-help genre, a Unitarian Minister in Manhattan reported, 'Judging from my counseling sessions over the past two years, fear's grip is tightening. Never have I encountered a higher general level of fear. It extends across all ranks. Surely 9/11 is responsible for fear's heightened presence among us, but other factors are at work as well. An unpredictable economy affects our sense of future security, as do rapid cultural and geopolitical change. Fear thrives on uncertainty.'[16]

One of Solakov's very few direct references to current political situations, #43, begins, 'A president of a SuperPower just saw a hidden weapon for mass destruction (overseas, of course)' but breaks off with '… I better stop now,' thereby enacting for the reader his own apprehensions of challenging authority.

Over recent years, another source of communal fear has become prominent. Disastrous flooding, hurricanes and other atypical weather patterns have made the long-range disaster of disrupted ecosystems loom large in media coverage, including Al Gore's film and bestselling book *An Inconvenient Truth*, prompting the new vogue for products and procedures that are ecologically sustainable. The catalogue for a large exhibition surveying contemporary photography and video, 'Ecotopia', discusses artists' current 'fear of / for nature.'[17] Modern mainstream culture has come a long way

since the Middle Ages and should no longer be susceptible to predictions of an apocalyptic cataclysm. Yet interminable militaristic engagements in Iraq by Western democratic superpowers, simmering atmospheres, melting ice caps, shrinking oil reserves and species extinctions portend a topsy-turvy end of the world as we have known it. In *Liquid Fear*, Bauman writes, 'Living in a liquid modern world known to admit only one certainty – the certainty that tomorrow can't be, shouldn't be, won't be like it is today – means a daily rehearsal of disappearance.'[18]

We are living in quite terrible times. To be alert today is to take account of how dangerous the world is. On the other hand, culture is capable of responding to, articulating, and shedding light on those dangers and on the violence of all around us.
Robert Storr, curator of the Venice Biennale, 2007 [19]

THE VALUE OF ART ABOUT FEAR

Our entry point in the *99 Fears* is childhood, with the drawing on the first page voicing what is probably humans' first fear, developmentally: 'Sometimes it is pretty scary to be alone,' said the little fear.' (#1) 'Scary' is a child's term and describes an experience confronted repeatedly in the process of discovering the world and growing up. In Marina Warner's cultural and psychological analysis of myths, legends and fairy tales *No Go the Bogeyman*, which identifies 'three of the principal methods of coping with anxieties grounded in common experience', the first basic tactic she discusses is the allure of being scared. 'That children's word "scary" covers responses ranging from pure terror to sheer delight, and the condition of being scared is becoming increasingly sought after not only as a source of pleasure but as a means of strengthening the sense of being alive, of having a command over self.'[20] Hence the continued popularity of folklore (Little Red Riding Hood encountering the Big Bad Wolf), movies (*Dracula*) and children's literature (the Harry Potter series) with characters and plots that allow readers and viewers the thrill of confronting a fearful

situation, being scared, and yet remaining safe. Similarly, a positive value of examining Solakov's images of fear is that they increase consciousness of conditions that provoke it, and of the ensuing state of being fearful, and aid resistance to their disabling effects.

The second technique of confronting fear identified by Warner, that of 'lulling' or comforting lullabies, is evident in the visual and verbal charm of this body of images as a whole. The goal is exemplified in #56, where a small man has transformed a larger predator into a leashed pet. The third maneuver, of humorous 'mocking', is also a prevalent as a defensive strategy. Captions ridicule the 'fearless adventurer' who will be killed in a coming avalanche (#9), the inert insect, 'only 3 of her tentacles feel[ing] a bit of fear', who is waiting on the kitchen floor to be smashed (#42), and the anthropomorphic 'creatures [who] have fear of nothing. Are they happy? Not really.' (#15)

Obviously, Solakov is also reclaiming fears as sometimes appropriate, useful for personal safety. Across the series it also becomes evident that fear – like cholesterol, demonized by health fanatics until research distinguished between the 'good' (HDL) and the 'bad' (LDL) – can be beneficial as well as destructive. This is a position advocated by Gavin de Becker, who in *The Gift of Fear* responds to the current social mood by drawing upon his professional expertise in predicting violent behavior to urge readers to be receptive to personal intuitions of danger.[21] This useful self-protection is not like the excessive, irrational fears that constrict one's life, creating a phobic state of paralysis, like the 'poor country' in #60 that can't decide which light to follow in a dark tunnel. One learns – as in #37's balloon and cactus, a potent metaphor of a marriage of opposite sociabilities – not to fear difference but to accommodate. If you are lucky, you have opportunities to deposit your fears as you would a coat in a public cloakroom, as have the couple dancing together in #5: 'They left all their daily fears aside to feel more free and relaxed. They will collect the fears back later.'

Of his relation to his viewers, Solakov has said, 'I try to draw the viewer into a process which depends on him. Years

ago I had anxieties about whether the viewer and I were "in contact." Now I stopped posing that question and I express my fears and desire without shame and discomfort. Many of the viewers return this sincerity, and that creates our contact. Sharing reduces fear.'[22] Put more formally, media critic E. Anne Kaplan has argued against 'an insistence on the "unspeakability" and "unrepresentability" of trauma. Telling stories about trauma, even though the story can never actually repeat or represent what happened, may partly achieve a certain "working through" for the victim. It may also permit a kind of empathetic "sharing" that moves us forward, if only by inches.'[23] As much as this series may serve as consciousness-raising about the presence of fears in our lives, the images can also be thought of as functioning for both the artist and the viewer as acts of exorcism, aiding recognition, understanding and, ultimately, control of fearful reactions.

In Solakov's #40, an image with the simple masses and darkly expressionistic tenor of a graphic novel, a man opens a door onto a dark night. '"I feel very insecure stepping outside in the darkness," says the man. "Shut the door! Your light is killing me!" The darkness replies by sending vibes to the man. "This is it – I got goose bumps," the man mumbles and steps back into the house leaving the door open.'

Temporarily, darkness – ignorance, stupidity, fear – has suppressed the protagonist's adventurousness. But in leaving the door open, anything can happen. This very ambiguity, prompting reflection as much as amusement, is what distinguishes fine art from more psychologically simplistic forms of visual culture. At times tender, sardonic, juvenile and wise, these pages reveal a complex artist modeling confrontation and introspection. Addressing the primary emotion of fear in the basic medium of ink and paper, this sophisticated project doesn't offer reductive prescriptions but more authentically incorporates uncertainty. Not fearing his own fears, Solakov displays the way toward courage.

1. Iara Boubnova, 'Interview', in *Nedko Solakov: A 12-1/3 (and even more) Year Survey*, Folio, Vienna, 2003, pp. 83, 76.

2. The association ended when Solakov refused to be transferred from reporting to an army officer (he spent two years in the army after the Academy) to one responsible for intelligence-gathering among the intelligentsia. Before he made *Top Secret* he was in no danger of being disclosed. There are no publicly known documents about his collaboration other than this work of art, and the files in Bulgaria are still closed. Notes to author from the artist, October and December 2007.

3. Nedko Solakov, 'The Action is on (for the time being) . . .' in Laura Hoptman and Tomáš Pospiszyl (eds.), *Primary Documents, A Sourcebook for Eastern and Central European Art since the 1950s*, the Museum of Modern Art, New York, 2002, p. 279.

4. Artist's note to author, October, 2007.

5. Interestingly, Solakov insists that in regard to the images discussed in this paragraph and the previous one, 'these references are not related to socialism.' Note to the author, December 2007.

6. Nedko Solakov, *The Thief of Art*, Arken Museum of Modern Art, Ishøj, 1996.

7. Personal communication to the author, August, 2007.

8. Andrew Ortony, Gerald L. Clore and Allan Collins, *The Cognitive Structure of Emotions*, Cambridge University Press, 1990, pp. 109–114.

9. William G. Naphy and Penny Roberts, 'The Disease of Fear', *Fear in Early Modern Society*, Manchester University Press, 1997, p. 201. They quote Jean Delumeau, *Le Peur en Occident: XIVe - XVIIIe siècles*, Paris, 1978, p. 114.

10. The reference to Orvieto was provided by Professor Alan Wallach of the College of William and Mary, a fellow member of the Consortium of Art and Architectural Historians, others of which were also helpful in identifying historical images of fear.

11. Zygmunt Bauman, *Liquid Fear*, Polity Press, Cambridge, England, and Malden, Massachusetts, 2006, p. 2. Bauman quotes Lucien Febvre, *Le Problème de l'incroyance au XVIe siècle*, A. Michel, Paris, 1942, p. 380.

12. Bauman, p. 2.

13. Bauman, p. 20.

14. Vladimir Shlapentokh, *Fear in Contemporary Society: Its Negative and Positive Effects*, Palgrave Macmillan, New York, 2006, p. 135.

15. Susan Faludi, *The Terror Dream: Fear and Fantasy in Post-9/11 America*. Metropolitan Books and Henry Holt and Company, New York, 2007.

16. Forrest Church, *Freedom from Fear: Finding the Courage to Act, Love and Be*, St. Martin's Press, New York, 2004, p. xiv.

17. 'The very subjects of landscapes, nations and even climate are fraught with paranoia and other anxieties. In this respect, the idea of a contemporary benign landscapes is dubious.' An-my Lê in 'Ecotopia: A Virtual Roundtable', *Ecotopia: The Second Triennial of Photography and Video*, International Center of Photography, New York, and Steidl, Germany, 2006, p. 17–18.

18. Bauman, pp. 6, 2.

19. Robert Storr, 'Biennale de Venezia: Opening Remarks', *Brooklyn Rail*, July/August 2007. Solakov participated in the exhibition Storr curated at the Biennale, 'Think with the Senses, Feel with the Mind: Art in the Present Tense.'

20. Marina Warner, *No Go the Bogeyman: Scaring, Lulling, and Making Mock*, Farrar Straus Giroux, New York, 1998, p. 6.

21. Gavin de Becker, *The Gift of Fear: Survival Signals That Protect us from Violence*, Little, Brown and Company, New York, 1997.

22. Boris Danailov, 'Nedko Solakov', *Flash Art*, no. 171, summer 1993, p. 98

23. Ann E. Kaplan, *Trauma Culture: The Politics of Terror and Loss in Media and Literature*, Rutgers University Press, New Brunswick and London, 2005, p. 37.

Author's acknowledgements: The expansive international exhibition Documenta, in the summer of 2007, provided the venue for my discovery of Nedko's work. As one of a number of critics at the press preview absorbed by these drawings, I immediately knew they should be published for the appreciation of many others within and beyond the art world. Because Nedko was one of the artists present during those few days prior to the public opening, I was able to meet him and talk about this work. So first I would like to thank the citizens of Kassel who support the dynamic Documenta programme every five years and otherwise make the city such a hospitable and beautiful destination. At home in New York, the extraordinary collections in the libraries of the Museum of Modern Art and the New York Public Library's Humanities Research Center allowed me, as I could not have done in any other place in the United States, to have immediate access to an extensive array of exhibition catalogues and periodical articles on Nedko's work; MoMA's librarians are particularly responsive to a scholar's needs. Throughout, Nedko himself was informative; Kristin Rieber, at his gallery in Berlin, Arndt & Partner, has been a gracious and generous facilitator. I appreciate that my editor at Phaidon, Craig Garrett, has indeed related to me, as his emails conclude, with 'kind regards.' Rita Rosenkranz, literary agent, and Larry Miller, copyright attorney, offered useful counsel. This book is dedicated to David Dorfman, my beloved husband who understands my need to travel distances to discover delights such as Nedko's *Fears*, and who is ever a solace to my own.

Phaidon Press Limited
Regent's Wharf
All Saints Street
London N1 9PA

Phaidon Press Inc.
180 Varick Street
New York, NY 10014

www.phaidon.com

First published 2008
© 2008 Phaidon Press Limited
All works of Nedko Solakov are © Nedko Solakov

ISBN: 978 0 7148 4888 4

Printed in China

Artist's Acknowledgements
I would like to express my deepest gratitude and love to
Vesselina and Dimitar Solakov, Slava Nakovska and my
parents for their love and for constantly trying to take away
my fears; I wish to thank Matthias Arndt and Kristin Rieber
from Arndt & Partner Berlin/Zurich, and Maurizio Rigillo
from Galleria Continua, San Gimignano/Beijing, for the
trust and the support of the *Fears* body of work; and to Roger
M. Buergel and Ruth Noack for letting me expose this
series of drawings to the widest possible audience during
Documenta 12; and to Richard Schlagman, Craig Garrett
and Lupe Núñez-Fernández from Phaidon Press, who made
this book possible, eliminating at least one of my fears; and
to Suzaan Boettger for the wonderful essay which makes my
stories feel comfortable and significant. My deepest hope
goes to Enea Righi – who owns the actual drawings – that he
will keep all the fears in a good, sound shape for the future.

The publisher would like to thank Kristin Rieber at Arndt &
Partner Berlin/Zurich; Galleria Continua, San Gimignano/
Beijing; E. Righi Collection, Italy; and Bernd Borchardt,
Berlin.